PAST & PRESENT

SPRINGFIELD

OPPOSITE: Construction of the Pythian Home of Missouri was completed in 1913. Built by the Order of Knights of Pythias fraternal club, it was a home for widows and children of club members. This undated image appears to be a special event, likely when the building was new. In the 1940s, the Pythian Home was used by nearby O'Reilly Hospital as a service club. It is now privately owned and hosts special events. (Courtesy of the Library Center.)

PAST & PRESENT

SPRINGFIELD

Connie Yen

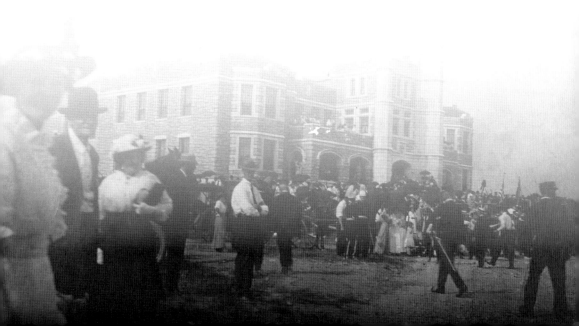

For Alix and Andrew

Library of Congress Control Number: 2022938420

Published by Arcadia Publishing
Charleston, South Carolina

Printed in the United States of America

For all general information, please contact Arcadia Publishing:
Telephone 843-853-2070
Fax 843-853-0044
E-mail sales@arcadiapublishing.com
For customer service and orders:
Toll-Free 1-888-313-2665

Visit us on the Internet at www.arcadiapublishing.com

ON THE FRONT COVER: The cornerstone of the Midtown Carnegie Library was laid in 1903. This was one of over 1,600 such libraries built across the United States with funding from Andrew Carnegie, who donated $50,000 for the construction of this library on what was then Center Street. The library opened to the public in 1905. In 1937, additions on the east and the west side of the building were added. (Past image, courtesy of the Library Center; present, courtesy of Jimmy Yen.)

ON THE BACK COVER: The Farmers and Merchants Bank building was erected around 1891 and was located on the northeast corner of Campbell Avenue and Walnut Street. The bank may have been located on the second floor; the image shows a grocery store on the left side of the building. The old bank was demolished in the 1990s. The current building has a large outdoor patio and serves as an event center. (Past image, courtesy of the Library Center; present, courtesy of Jimmy Yen.)

Contents

Acknowledgments vii

Introduction ix

1. Public Square 11

2. Education and Religion 17

3. Businesses 29

4. Streetscapes 63

5. Around Town 81

ACKNOWLEDGMENTS

My deepest thanks to the Library Center for the generous use of its image collection. Special thanks to Ben Divin and Brian Grubbs of the Library Center for their assistance with this project.

Unless otherwise noted, all historical images appear courtesy of the Springfield-Greene County Library District, and all current images appear courtesy of Jimmy Yen. The historical images obtained from the Greene County Archives will be labeled as GCA.

A special thanks to my husband, Jimmy Yen, for his unfailing support of this project and for happily taking so many photographs.

INTRODUCTION

In 2021, Missouri celebrated its 200th anniversary of statehood with celebrations across the state. Greene County was established on January 2, 1833, and Springfield was designated the county seat in 1835, although it was not incorporated until 1838. Both the county and the city are quickly approaching a major milestone—200 years of history. Within just a few years, it will be time to start planning local celebrations. Therefore, this is good a time to begin reflecting on what has been lost and what remains of Springfield's architectural history.

William Fulbright built the first log cabin in Springfield around February 1830 in the 1200 block of West College Street. The cabin is long gone, but a historical plaque marks the location and serves as a reminder of the earliest day of the city's history. The oldest extant structure is the Gray-Campbell cabin, built by James Price Gray in 1856. Gray sold the cabin to John Polk Campbell, the nephew and namesake of Springfield founder John P. Campbell. Thankfully, this piece of history has survived and been preserved, possibly due to its continued use as a family home until the 1950s. In 1984, the cabin was moved to Nathaniel Greene Park and is now part of the Springfield-Greene County Park Board system. This move ensures the survival of this important part of local history.

Springfield has lost some of its most historically important and beautiful buildings, such as the train depot on Main Street. When the last train left the depot in December 1967, the Spanish Mission–style building sat vacant and derelict for a number of years. Due to the importance of railroads in Springfield history, the old depot, built in 1927, was placed in the Springfield Historic Sites Registry in 1975. That did not prevent its destruction in 1977.

Obviously, a historic site listing does not prevent the loss of history. The once famous Colonial Hotel was a registered site, but that did not save it from being demolished in 1997. The Fairbanks House on Sherman Avenue was the home of Jonathan Fairbanks, a Springfield education pioneer. The house was built in 1869 and is significant in Springfield history, enough so that it was moved once so that it could be preserved. Eventually, area progress meant another relocation was required. Relocation efforts failed, and the Fairbanks House was demolished in 1997.

Often, it is the cost of renovations that prevent Springfield's old buildings from being preserved. This is evident with the current efforts to rehabilitate the Jefferson Avenue Footbridge. Fortunately, this 120-year-old structure has champions working toward its preservation and reopening.

Of course, progress and modernization are inevitable and necessary, but saving old structures, while costly, is worthwhile and may also be profitable. Commercial Street was once the hub of North Springfield but experienced a decline in the 20th century. Now, many of the old buildings have been restored and filled with shops and local restaurants. The history of the street is part of what makes the area so appealing, not just to locals but to tourists as well. That history sells should not come as a surprise. Route 66 is an example; a once forgotten highway now attracts visitors from around the world.

The resurrection of Commercial Street is echoed in downtown Springfield on the public square and surrounding streets. The growth and changes of this historical area are evident in the then and now

photographs. So many buildings have been replaced by parking lots, but many remain and carry national historic designation. That designation alone may not save Springfield's historical structures, but an interest in local history can. Historical areas of cities and towns across the country, and the world, are tourist magnets when local governments and citizens become involved in restoration efforts.

The images in this book are a reminder of the multitude of changes and past disregard for Springfield's architectural history. They also serve as a reminder to be thankful for the structures that still remain and for those who work to preserve local history.

PUBLIC SQUARE

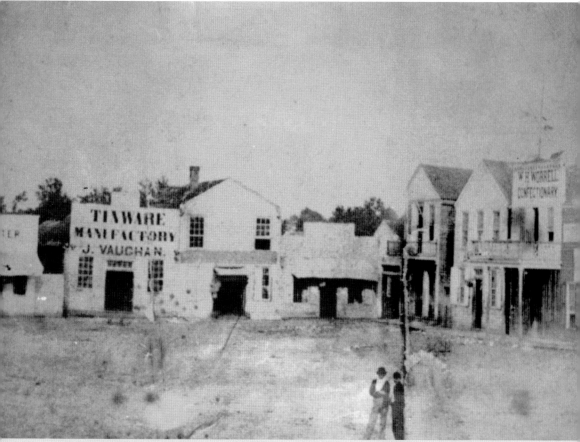

This oldest known image of the square is dated between 1865 to 1870. For over 150 years, the southeast corner of the square has undergone numerous transformations. Shops of all kinds still surround the center, but the wooden buildings have long since been replaced. These days, the square is often filled with music and celebrations, such as the Route 66 Festival.

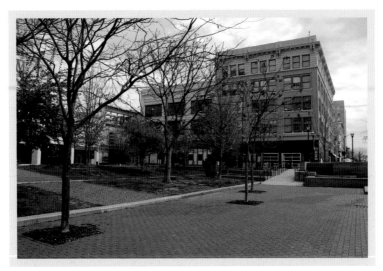

All of the buildings on the northeast side of the public square date from 1914, due to the fire that destroyed the entire section in June 1913. The Holland Building and structure to its north, Reps Dry Goods Company, were both completed in 1914. The present Fox Theatre was built in 1916 as the Electric Theatre. In 1930, it was bought by Paramount, which is the name it has in this 1931 image.

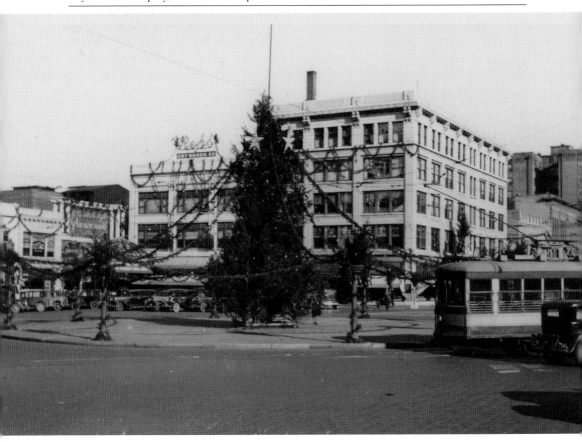

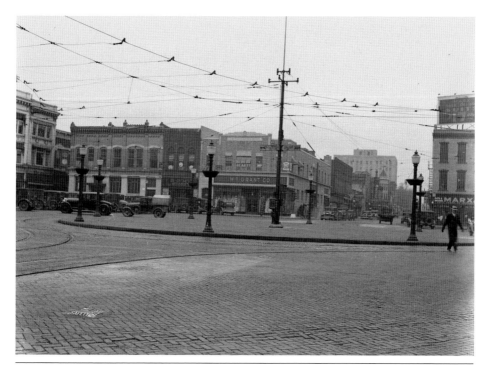

This 1934 image shows part of the southeast corner of the public square. W.T. Grant was a national chain department store that opened in Springfield in 1931. The company went bankrupt in 1976. Next door was Leon's Shoes and Union National Bank. The concrete "pie" in the center was constructed in 1909 by the Springfield Traction Company. The pie was removed in 1947 to allow traffic to drive through the square.

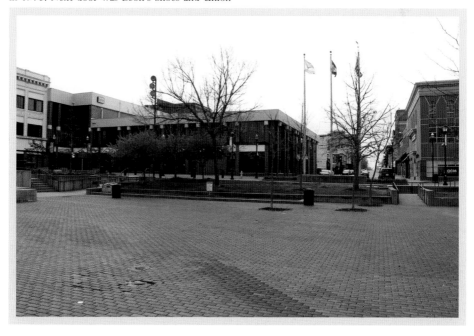

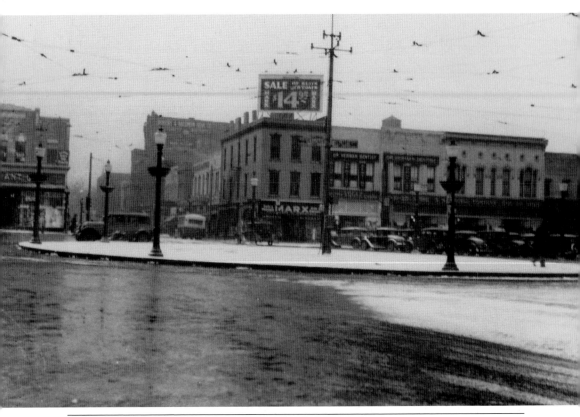

In this 1933 image, Marx Clothing Company is located on the corner of the southwest side of the square. Eventually, it would be replaced by the Betty Gay Shop. Next door is Lerner's Vogue Shop, now the Coffee Ethic. The former Kresge store is the largest of the shops and was a longtime fixture on the square. In the distance is the Rogers-Baldwin Hardware Company. All of these buildings are still standing, though the appearance of some has changed considerably.

It is hard to miss the 10-story Landers Building on the northwest corner of Boonville and the square. Built in 1915, the Landers has been home to a variety of offices and businesses in its 100-plus-year history, including Evans Cut-Rite Drug Store. It is likely most well known as a Missouri Department of Motor Vehicles location. The undated past image shows a building that was usually a bank as well as business offices, a jewelry store, and city hall. (Past image, courtesy of the GCA.)

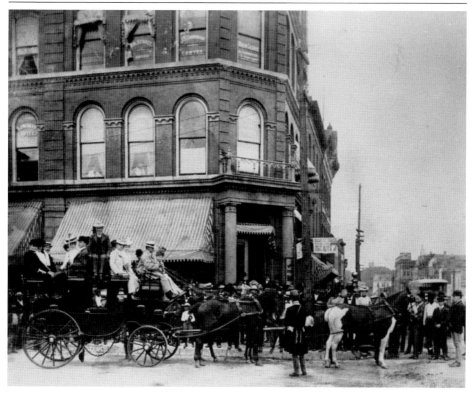

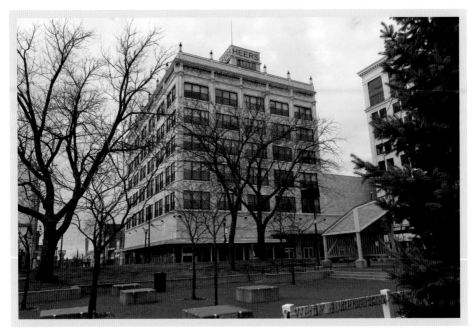

In January 1861, Greene County offices moved into this new courthouse at the northwest corner of College Street and the square. By 1903, the building was already in disrepair and had become obsolete. County offices again relocated, and this building was demolished. In 1915, Heer's Department Store opened at this location. Although the store closed in 1995, the building was repurposed and is now home to Heer's Luxury Living apartments. (Past image, courtesy of the GCA.)

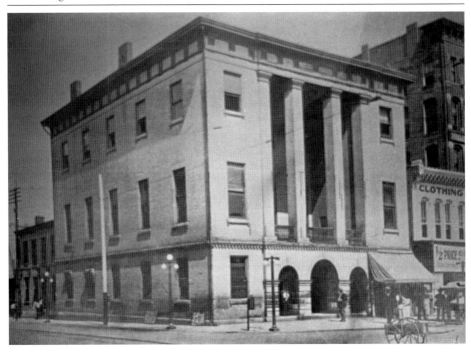

CHAPTER

2

EDUCATION
AND RELIGION

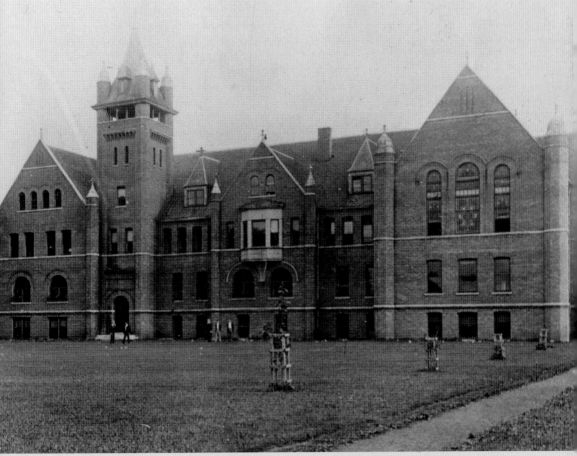

This 1906 image is of the Springfield Normal School, built in 1894 at the northeast corner of Cherry Street and Pickwick Avenue. In January 1906, the school merged its business department with the Queen City Business College, creating the Springfield Business College. In 1907, the Springfield Normal School was taken over by the State Normal School. The building was demolished in 1916.

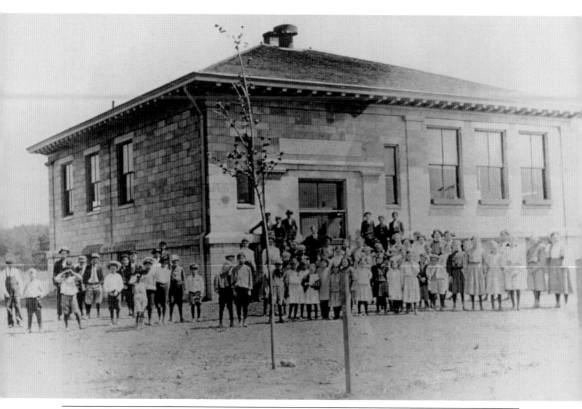

The current Rountree Elementary School has been a fixture of the Rountree neighborhood since 1917. It replaced Pickwick School, built in 1906 due to overcrowding and poor sanitation. A suggestion that the old school be converted into a community center was discarded in favor of building a new school in the same location. The school is named for the grandson of Joseph Rountree, who started the first school in Greene County. (Past image, courtesy of the GCA; present, courtesy of EJB Photography.)

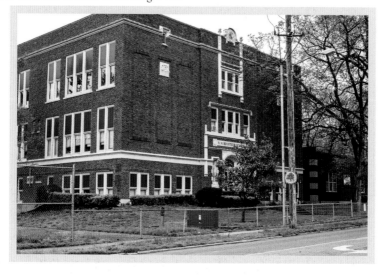

EDUCATION AND RELIGION

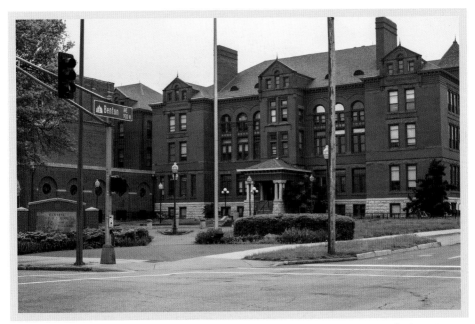

Boyd Elementary opened in 1908 and was named for Mary Sophia Boyd. The school was originally in a large, former home at the northwest corner of Central Street (then Center) and Benton Avenue. That building was damaged by fire in 1911, and a new one was erected on Washington Avenue. The corner that was once home to Boyd School has since been filled with the Central High School expansion. (Past image, courtesy of the GCA; present image, courtesy of EJB Photography.)

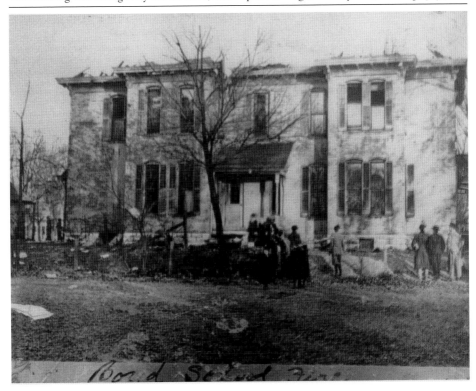

Construction began on Central High School, formerly Springfield Senior High, in 1893. It replaced the old Central High, which was built in 1871 at the corner of Jefferson Avenue and Olive Street. The new school was dedicated in January 1894, and it began with 76 students enrolled. Early additions were completed in 1907 and 1914. In 1916, more school rooms were added, and the bell tower was removed. The school has changed considerably, but it still stands at the northeast corner of Central Street and Jefferson Avenue.

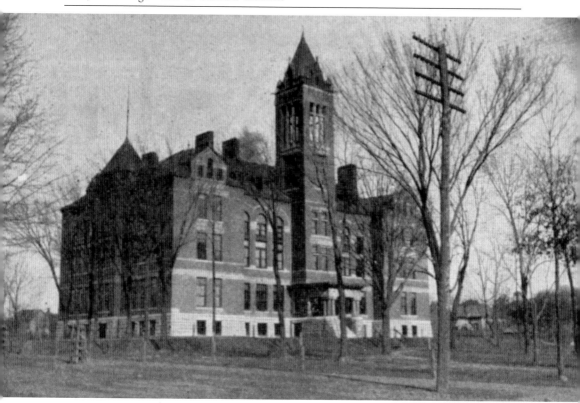

EDUCATION AND RELIGION

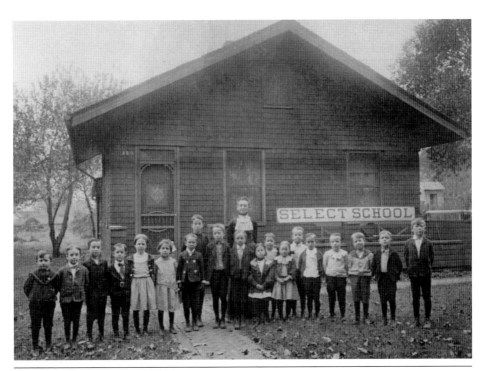

Julia A. Hovey-Colby taught at Campbell School for a number of years before opening her own school called the Colby Select School. She had a Swiss chalet–style home built on South Grant Avenue, and it was there she taught school until well into her 80s. She retired around 1922 and moved into the Mary E. Wilson Home. The Southside Baptist Church is now located where Colby's home and school once stood. (Past image, courtesy of the Piland Collection, GCA.)

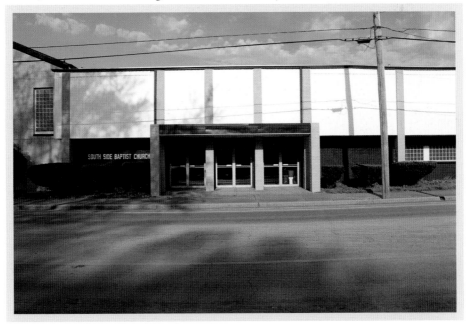

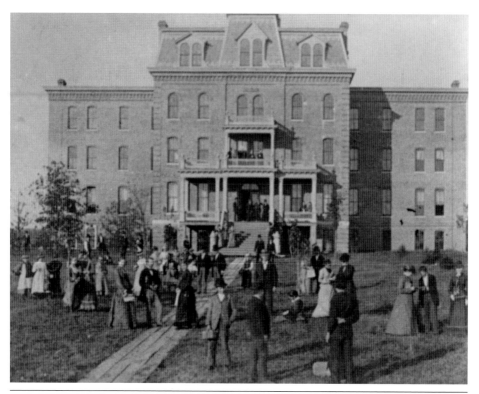

Fairbanks Hall, as seen in this 1880s image, was built in 1876 on the campus of what was then Drury College. Originally a female dormitory, it became a men's dormitory in 1884 and, later, Fairbanks' bookstore. In 1978, Drury trustees decided to demolish the over 100-year-old building due to its poor condition and the cost of renovation. There is now a marker indicating where the building once stood.

Wallace Hall was one of three new buildings opened on the grounds of what was then Drury College, now Drury University, in 1926. The building was named for its benefactors, Washington and Louise Wallace. The Wallaces were the foster parents of Clara Wallace Thompson, a former music student at Drury and the namesake of Clara Thompson Hall. Wallace Hall was the largest of the three buildings, which also included Harwood Hall. The building still stands and continues to be used as a dormitory.

St. Joseph's Church and College opened at the corner of Chestnut Street and Jefferson Avenue in 1893. Charles H. Heer, of Heer's Department Store, donated the lot and a house. The same building was used for church and school. A former stable was used as a parochial school until the space was outgrown. The St. Joseph's College building was used until 1898. In 1905, a new church and parochial school were built at Jefferson Avenue and Scott Street.

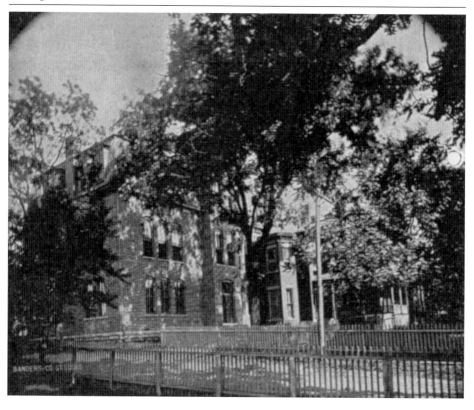

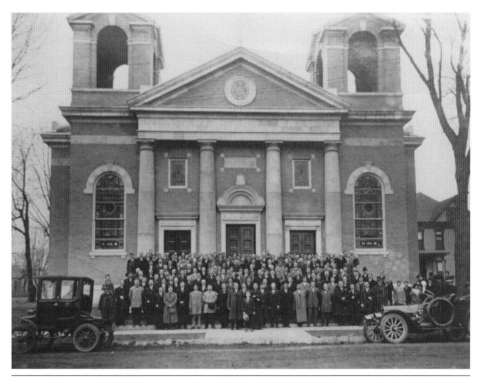

This 1910 image shows the new St. Agnes Church at the corner of Jefferson Avenue and Cherry Street (then Mount Vernon). Several prominent Springfield citizens, including F.X. Heer and John Landers, were instrumental in getting the church built. Plans were approved in July 1909, and the foundation was laid in October of that year. The church was officially dedicated on Thanksgiving Day, 1910. Although it has undergone a few changes, it still stands and is now known as St. Agnes Cathedral.

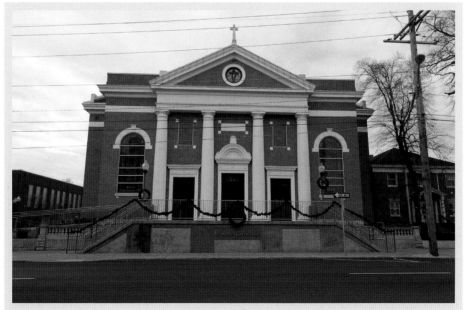

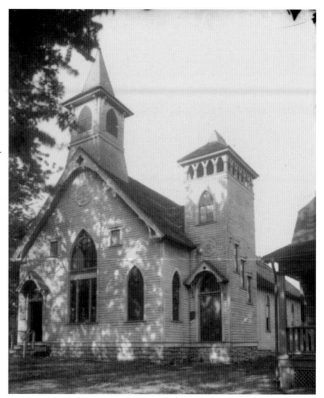

Robberson Avenue Baptist Church was organized in the 1880s and met in this church on North Robberson Avenue since the early 20th century. It was the second Baptist church to be organized in Springfield, and in 1947, the congregation decided to change the name to Second Baptist Church. By 1961, the congregation had moved, and the church at North Robberson Avenue was sold. The building currently at that location was erected around 1950. (Past image, courtesy of the GCA.)

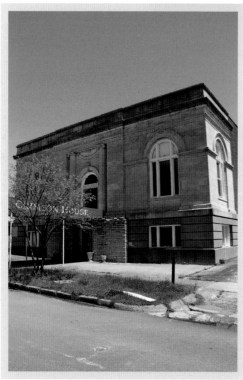

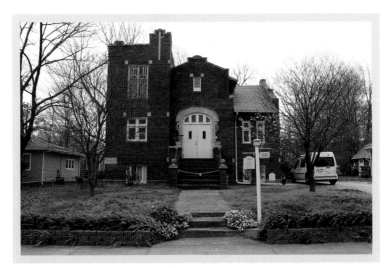

The former Trinity Lutheran Church was built in 1919 at the southeast corner of Jefferson Avenue and Webster Street. The cornerstone was laid in November of that year and contained a copy of the church constitution and a list of church officers and members, among other items. A dedication service was held the following May, which included a parade from their old church to the new. The building is now a private residence. (Past image, courtesy of the GCA.)

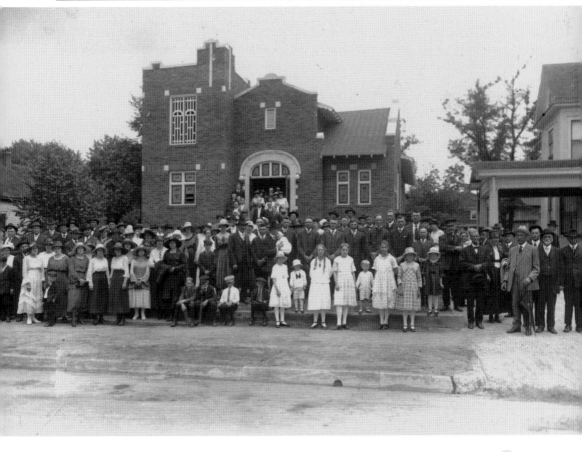

This beautiful church was completed in 1879 on the northwest corner of St. Louis Street and Benton Avenue, although it was not dedicated until 1882. It was in use until 1930, when the congregation merged with the First Presbyterian Church and relocated to the corner of Dollison Avenue and Cherry Street and became First and Calvary Presbyterian. By 1933, this building had been demolished, and the corner was an empty lot until eventually becoming home to a bank.

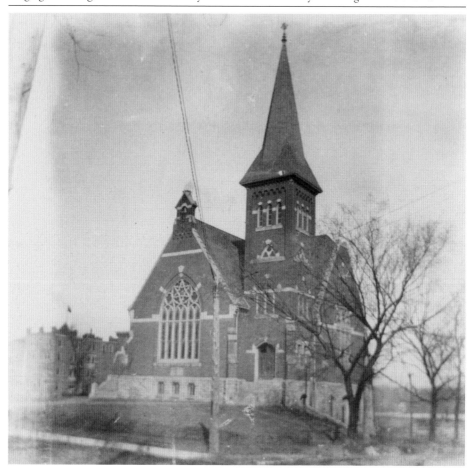

CHAPTER

3

BUSINESSES

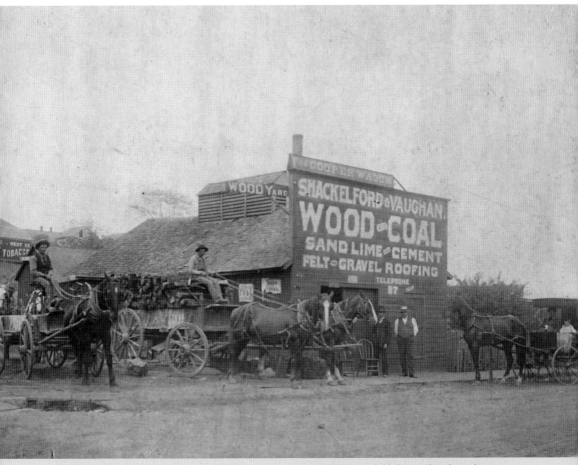

Shackelford & Vaughan was located at the southwest corner of Campbell Avenue and Mill Street, right next to railroad tracks. The company sold a variety of items, including coal and lime, and sold sand to the City of Springfield for roadwork. It does not appear to have been in business for more than a few years in the late 1890s.

The original Heer's store was a small shop built in 1869 by Charles H. Heer at the southwest corner of Boonville Avenue and Olive Street. It eventually grew to the three-story building seen here and was called the Charles H. Heer Dry Goods Company. The business later moved to the northeast side of the square but was destroyed by fire in 1903. Much of this corner is now taken up by the Landers Building, erected in 1915.

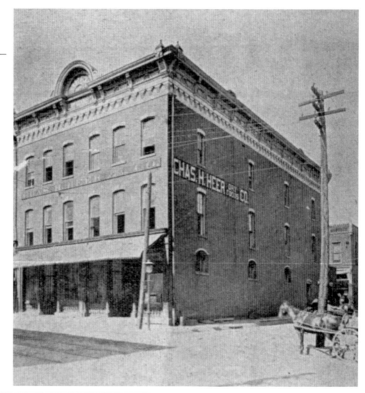

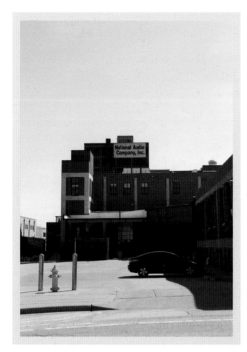

Melchior Steineger had a saddlery shop on the
southwest corner of the public square as early as
1884, after taking over the business of William
McAdams. In 1890, his company moved into
this new building at 410 Boonville Avenue. In
1900, Steineger sold the business to the Herman
Saddlery Company. Steineger died in 1912, and
by 1919, his former building housed the coffee
roasting department of the Springfield Grocer
Company. The location is now a parking lot.

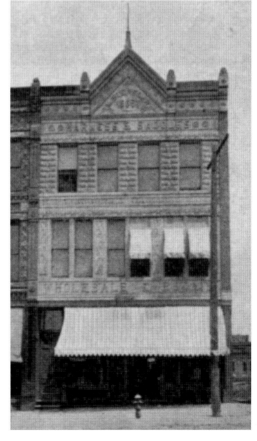

The Central National Bank was organized in 1887 and was originally located on Commercial Street. By the end of 1887, business was booming and the bank moved to a larger building at 320 North Boonville Avenue, as shown in this 1894 image. In 1899, the Greene County Abstract Company moved in; in 1905, it housed a piano company and, the following year, a print shop. By 1915, it was home to the Salvation Army. The location is now a parking lot.

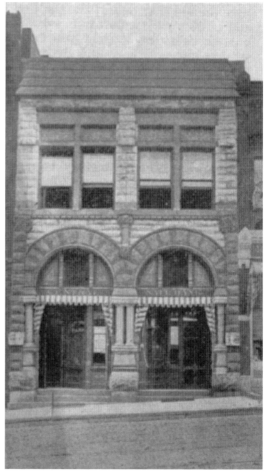

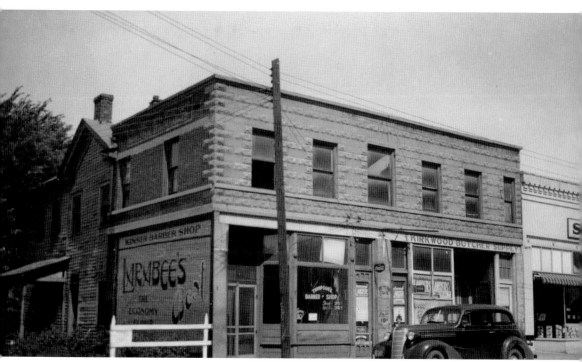

The Ben Freeman House was located at the northwest corner of Boonville Avenue and Brower Street. This undated image is likely from the 1930s, when Kinser Barber Shop and Kirkwood Butcher Supply were residents. Freeman lived upstairs with his sister, Myrtle Givens, until his death in the late 1930s. When he died, he was called "one of Springfield's pioneer retail clerks." The location of his building is now a parking lot.

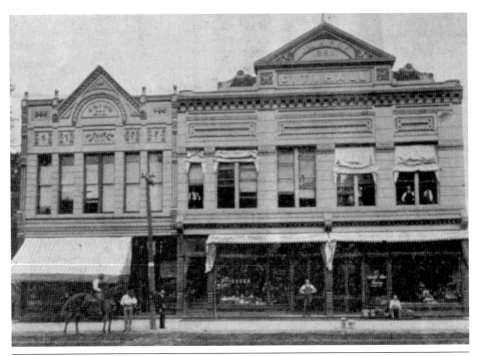

The building known as Kirby's City Hall, so named since city officials met in rooms upstairs, was located near the southeast corner of Boonville Avenue and Central Street as early as 1888. Part of the building was home to the City Hall Drug Company. By 1938, the entire corner was home to a new post office and federal building, later becoming the Jewell Station Post Office. City Hall Drug Company moved to another building across the street.

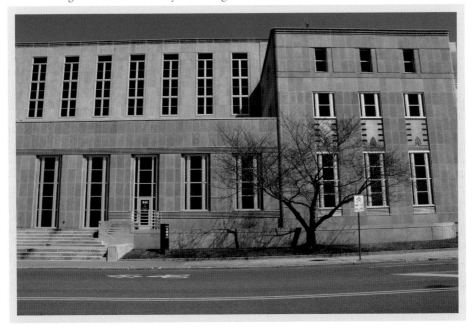

In 1938, the City Hall Drug Company relocated to an existing building at the southwest corner of Central Street and Boonville Avenue. The Classic Barber Shop and Courthouse Café moved as well. Midway Hotel was already in the building and had been since at least 1932. The hotel was still in operation through 1969. City Hall Drug Company closed when the building was sold in 1974. It was demolished in 1990 to make way for a parking lot.

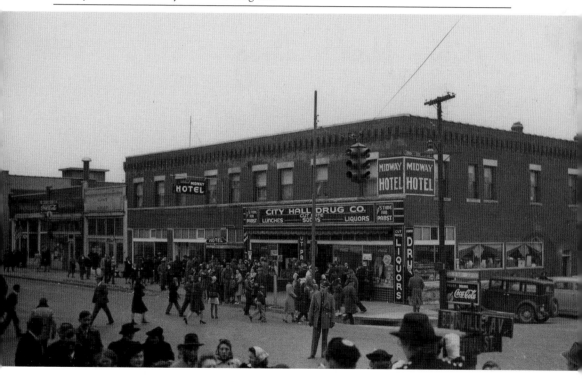

This 1938 image shows the St. Louis Auto Parts store, once located on North Boonville Avenue next to the former Germania Hall. From about 1920 to 1925, Germania Hall was New Harmony Hall. It was later home to Pythian Castle Hall, which housed numerous organizations, such as the Independent Order of Odd Fellows and United Garment Workers Local. St. Louis Auto was later Claybough Auto Supply. Both buildings are long gone, replaced by a parking lot.

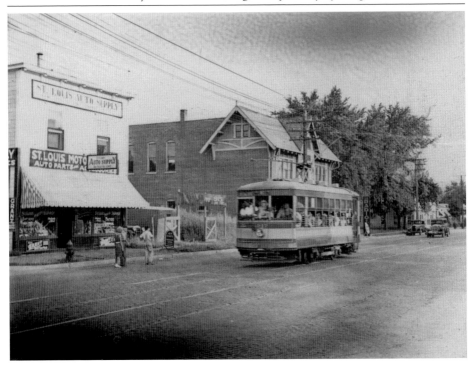

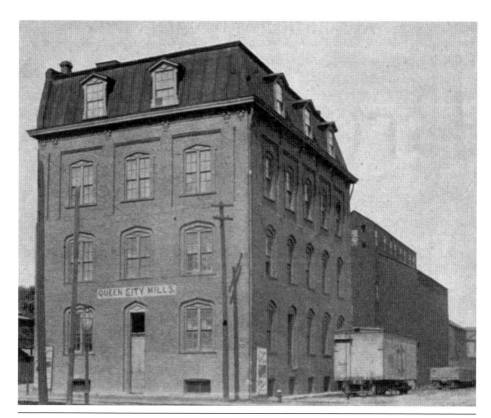

Queen City Mills opened in 1879 on the northeast corner of Boonville Avenue and Phelps Street. In 1901, the mill was owned and operated by John F. Meyer and Sons. The company won a gold medal at the Pan-American Exposition for its flour, Queen Bee and Meyers' Model. By the 1930s, the company had been succeeded by the Missouri Farmers Association Milling Company. The building was demolished in 1982. The lot is now occupied by the Jordan Valley Innovation Center and is owned by Missouri State University.

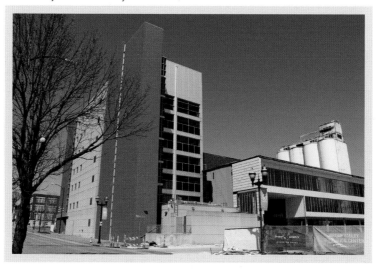

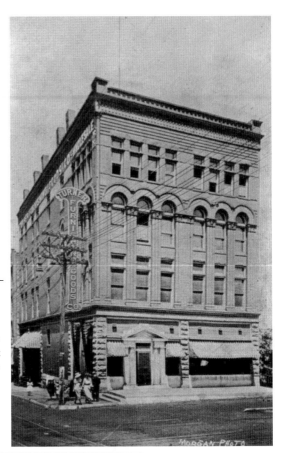

In 1903, the Jewell Nelson Paper Company moved to the first floor of this building on the northeast corner of Water Street and Boonville Avenue. It was previously occupied by the Springfield Hat Company. Several businesses subsequently came and went, but in 1917, Turner Furnishing Goods moved in, as seen in this 1919 image. In 1947, the building was destroyed by fire. The location is now home to a modern office building.

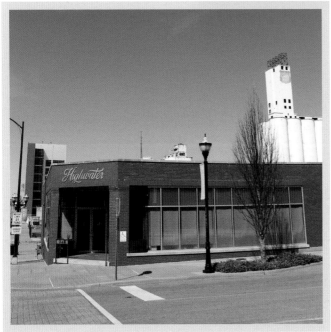

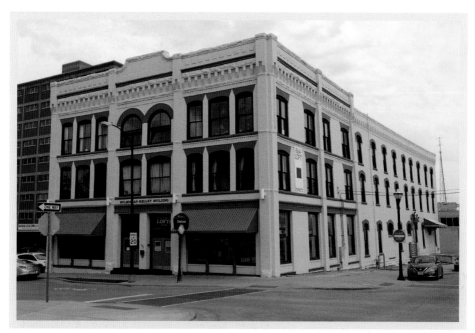

The Headley Grocery Company had this building constructed in 1891 for $30,000. The company went bankrupt in 1899, and the Milligan Grocer Company, organized in 1900, moved in. In 1940, Milligan relocated and Associated Grocer Company moved in. In 1956, the Paige E. Mulhollan Company opened a furniture store in the building and famously painted the front door red. The furniture store closed in the late 1990s. The building still stands and is now lofts.

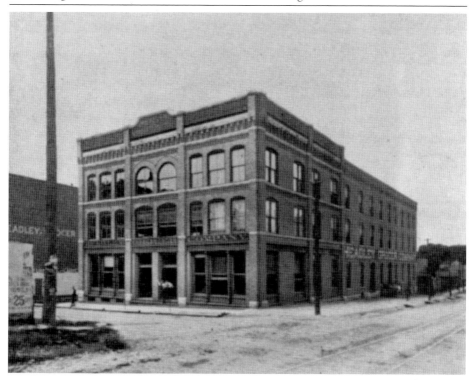

In 1886, Old Coon Tobacco Works moved into a new factory, as seen in this 1894 image. It was located at the northeast corner of Jefferson Avenue and Olive Street. By 1902, the tobacco factory was gone. Several businesses subsequently occupied the building, including Springfield Paper Company, which stayed from the 1920s to the 1950s. By 1970, a parking lot replaced the building. It is now home to an apartment complex.

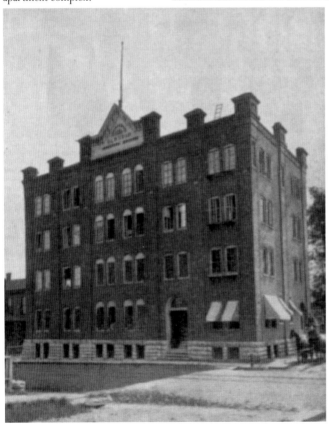

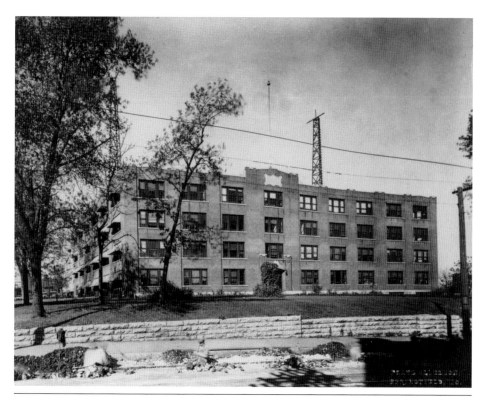

February 11, 1910, was a special day in Springfield. Three new buildings opened their doors for the first time and welcomed the public for tours. One of those was the Frisco Building, as seen in this undated image, located at the northwest corner of Jefferson Avenue and Olive Street. The Frisco offices relocated in 1964, and in 1966, this structure was renamed the Landmark Building. It still stands and is now Frisco Lofts. (Past image, courtesy of the Piland Collection, GCA.)

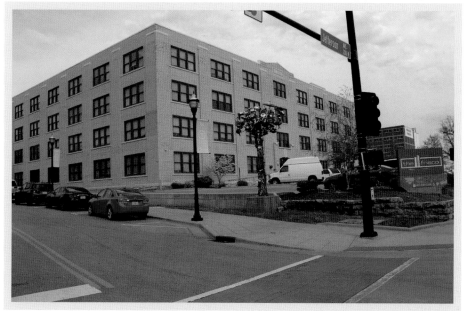

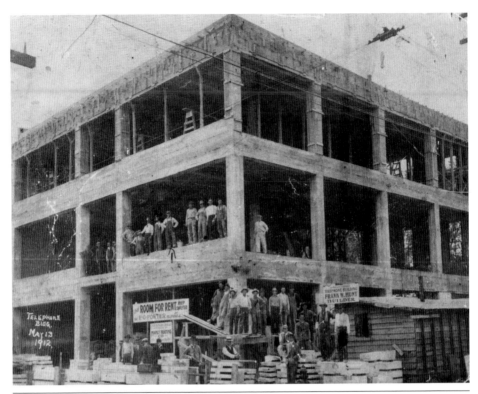

This 1912 image shows the Bell Telephone Building under construction at the southwest corner of Jefferson Avenue and McDaniel Street. The building was enlarged in 1926, and in 1947, two additional floors were added to the original three-story structure. In the early 1960s, Bell moved to a new location at St. Louis Street and Kimbrough Avenue. The Bell Telephone Building is now the Jim D. Morris Center and is part of the Missouri State University campus.

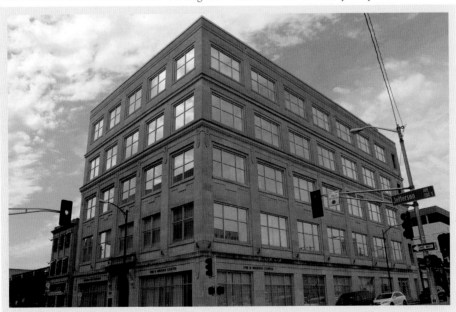

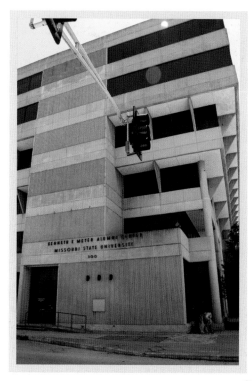

The undated image below shows Queen City Sign Company, once located at 408 Pickwick Alley, now McDaniel Street. This location would have been near the southeast corner of Jefferson Avenue and McDaniel Street. In 1914, the company relocated to 314 Pearl (now Robberson) Avenue and was at that location through at least 1919. The company was owned by Percy S. Porter, who was a member of the Master House Painters and Decorators Association. (Past image, courtesy of the Piland Collection, GCA.)

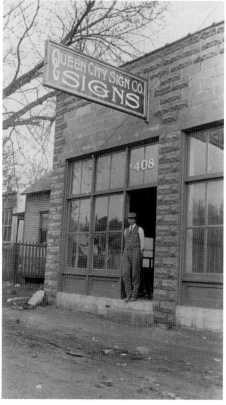

Pickwick Livery and Transfer Company was located on the southwest corner of Pickwick Alley, now McDaniel Street, and Peach Alley, now Robberson Avenue. J.L. Carroll was president of the company, with I.R. Hundall as secretary and W.T. Morrow as manager. The company picked up passengers and baggage at the train station and rented carriages. In April 1913, the company sold this location and moved to a new, three-story building at Olive Street and Robberson Avenue. (Past image, courtesy of the Piland Collection, GCA.)

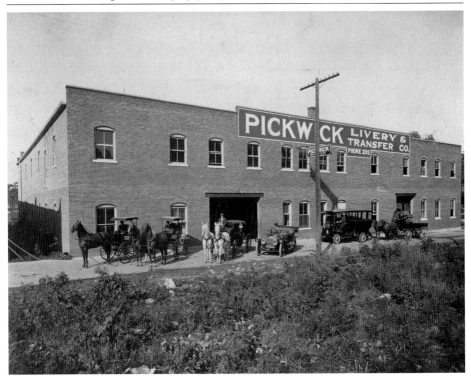

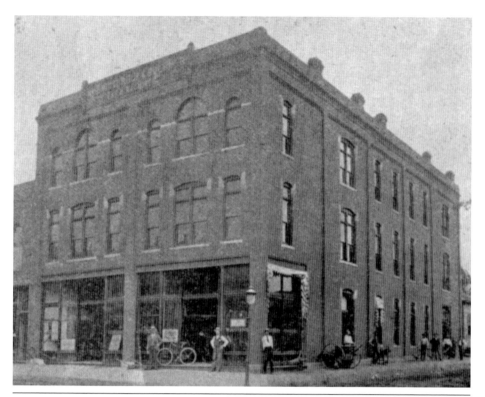

This beautiful c. 1888 structure is still standing, though it is currently vacant. It was once home to Koenigsbruck & Boehmer, a business that sold farm implements, buggies, and, later, bicycles. By 1894, the name changed to Ozark Implement Company. By 1902, the farm machinery company was gone, and Springfield Seed Company occupied the structure. The building is in the National Register of Historic Places and is one of the oldest in the area still extant.

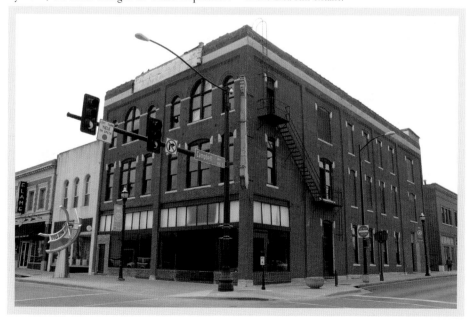

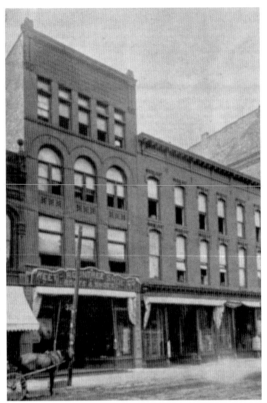

One of the most familiar structures in the downtown area is the Keet & Rountree Mercantile building, seen here in 1894. Keet & Rountree had been in business since 1859 and needed to expand to this larger building, erected in 1886 on the 300 block of South Avenue. Although the company was liquidated in 1934, the building still stands and still bears the later business name of Keet & Rountree Dry Goods Company.

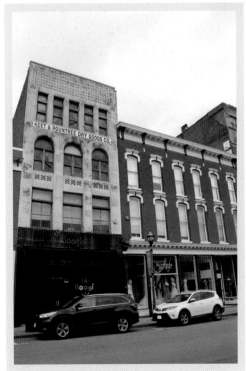

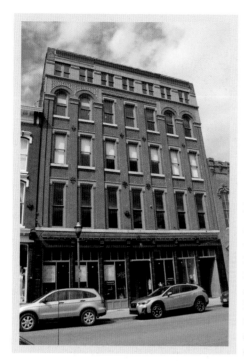

The Independent Order of Odd Fellows constructed this building in the early 1870s and used one floor for its meetings. Springfield Opera House leased the third floor in 1875, where Susan B. Anthony once spoke. In 1882, the new owner changed the name to Mansfield Opera House. Rogers & Baldwin Hardware Company acquired the three-story building in 1891 and added two additional floors, as seen in this 1894 image. The company stayed in the building for 65 years.

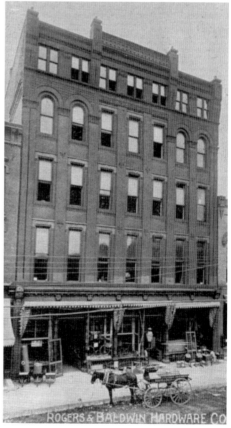

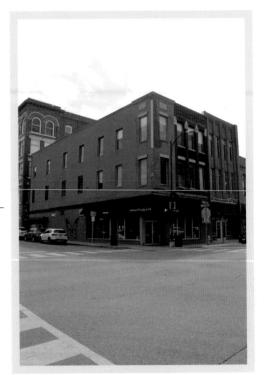

Williams Hardware had a presence in Springfield by 1887. In 1893, it moved to this new building at the southeast corner of South Avenue and Walnut Street. By 1902, it was renamed the Weaver-Raymond Hardware Company and, later, Cooper Brothers. For a short time, it was a hotel, and for many years, it housed the Missouri Home Savings & Loan Association. The building has undergone numerous changes over the years, but it still stands.

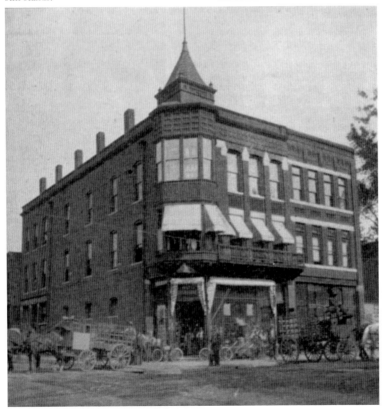

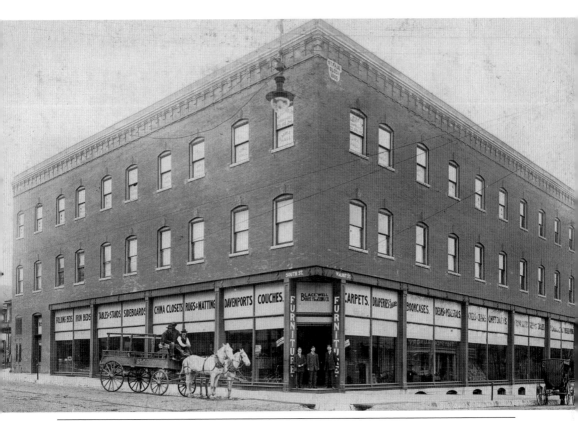

Now known as Wheeler's Lofts, the St. Paul Block still towers over the intersection of South Avenue and Walnut Street as it has since 1906. First owned by the Blackwell House Furnishing Company, Heer's also had a furniture division here. In 1926, the Hermann-Brownlow Saddlery Company bought the building, and in 1982, it was bought by Wheeler's Furniture, returning to its roots as a furniture store. (Past image, courtesy of the Piland Collection, GCA.)

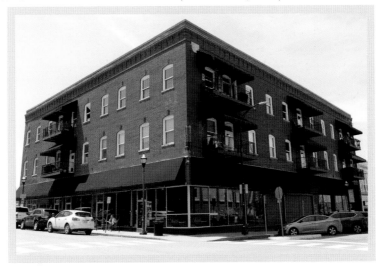

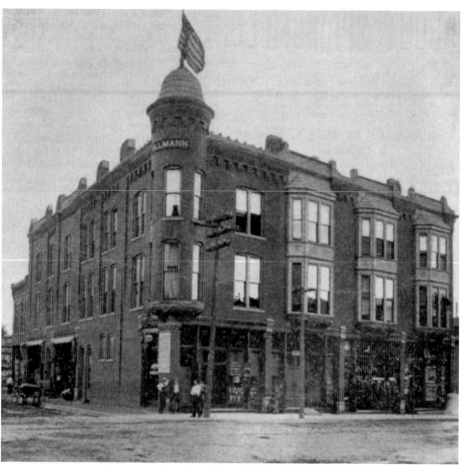

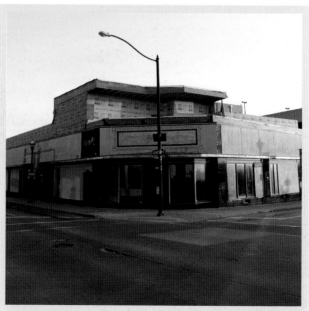

Construction of the Ullman Block building, located at the southwest corner of College and Campbell, was completed in 1889 and is shown here as it appeared in 1894. It housed several businesses, including a jewelry store and harness shop, and was also once a 40-room hotel. In 1947, the top two floors of the three-story building were removed and the remaining floor remodeled to house Rubenstein's Clothing Store. The first floor of the original building still stands and is currently undergoing renovation.

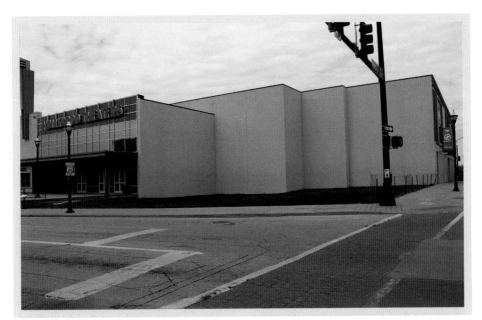

The new, three-story building of the Hawkins Brothers Furniture Company opened on the corner of College Street and Campbell Avenue in 1921. W.C. Hawkins, J.L. Hawkins, and Charles E. Wheeler managed the business. The Hawkins brothers first started the company in 1905 in a small building on Campbell Avenue. In 1928, Hawkins leased the building to the Sedgwick Furniture Company. By the mid-1950s, the building was gone, and a parking lot was in its place. The lot is now home to Hollywood Theaters.

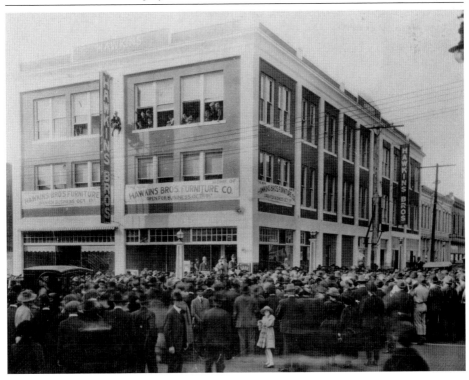

Globe Clothing House opened in 1887 on the southeast corner of the square. The building originally housed Rothschild & Company, succeeded by Frensdorf & Drucker. This building was later replaced by a large, three-story structure. In 1915, the owners decided not to renew the expensive lease and moved to a new location on South Campbell Avenue. By the 1920s, the corner was home to a bank. The current building houses offices and classrooms for Missouri State University.

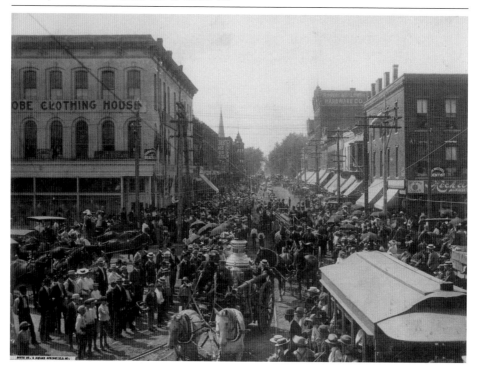

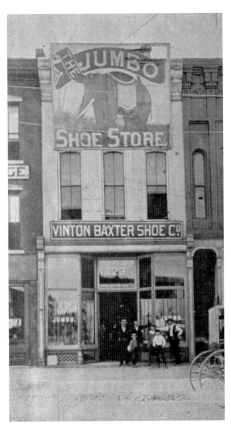

This 1894 image is of the Vinton-Baxter Shoe Company located on the public square. The building was constructed by at least 1890, when it was the Springfield Cigar Company. By 1891, the shoe store was on the ground floor and offices on the second floor. The building has been a store for most of its existence and has even housed a dentist's office. It continues to serve the public as part of the Park Central Branch Library.

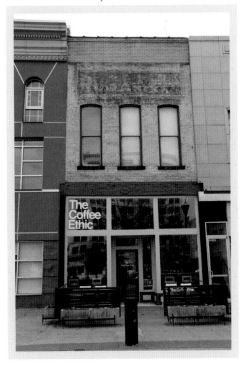

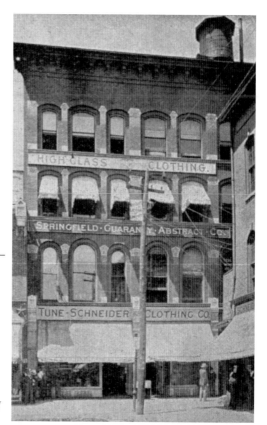

J.M. Tune and Henry Schneider first opened the Tune-Schneider Clothing Company in 1889. At that time, it was located at the northwest corner of the public square. In 1893, the company announced it would move to the opposite corner of the square, to the Baker Block, the location of this 1894 image. Schneider sold the business in 1919 and took over a store called Schneider-Foster Clothing. This portion of the Baker Block was eventually replaced by the Heer's expansion.

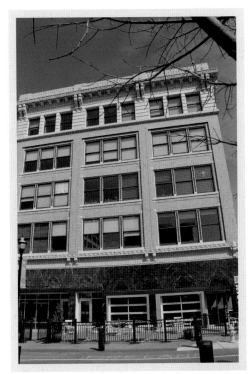

Colley B. Holland started a bank with his sons, T.B. Holland and W.C. Holland, in 1875. In 1896, the name changed from Holland and Sons to Holland Banking Company and was located on the northeast corner of the public square and St. Louis Street. A 1913 fire destroyed that entire corner of the square. In 1914, the Holland Building was constructed on the same corner at the behest of Louse Holland Jarret in memory of her father, Telmachus Blondville Holland.

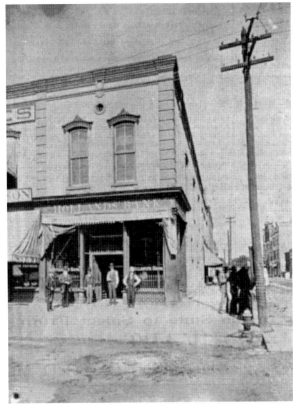

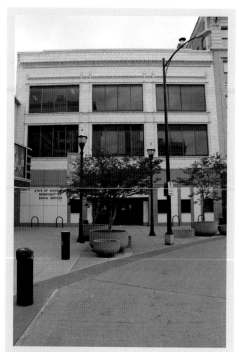

In 1894, the Model Dry Goods store was located in the Johnson Building on the northeast corner of the public square and had been in that location since at least 1888. The interior of the building was heavily damaged by fire in 1897 and was rebuilt as the Johnson Block, but Model Dry Goods moved to another location on the square. A 1913 fire destroyed the Johnson Block and the entire northeast section of the square.

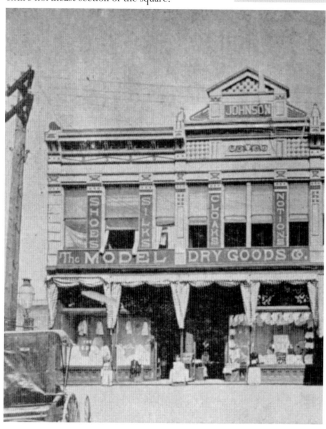

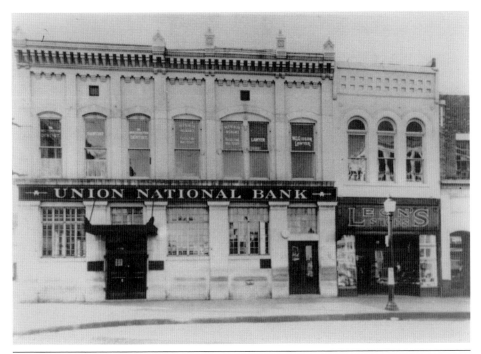

Union National Bank was located between the Post Office Arcade and Leon's Shoes by 1899. There were a variety of shoe stores in this building over the years, including Guarantee Shoe Company and W&W Shoe Company. The bank eventually took over the shoe store building. In 1950, the bank was modernized and unrecognizable from its previous iteration. The current building is the Park Central Office Building, part of Missouri State University. (Past image, courtesy of the Piland Collection, GCA.)

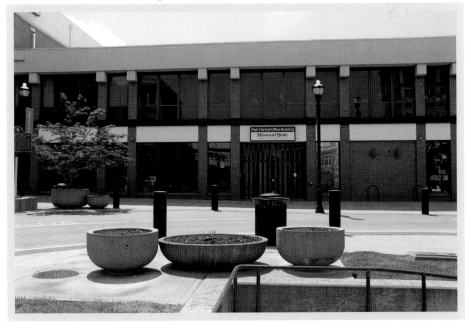

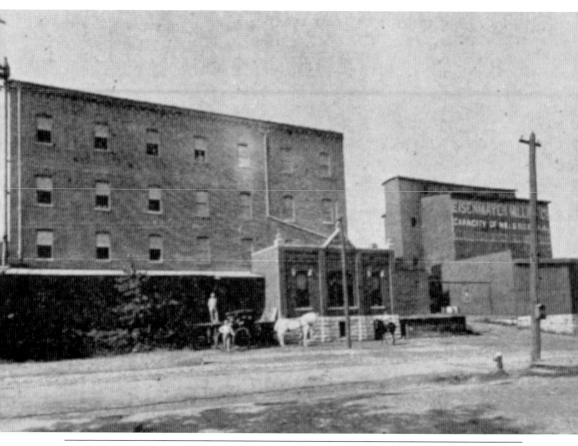

Eisenmayer Milling Company, owned by Andrew Eisenmayer, began operating in 1884 when he bought an already existing mill on Commercial Street near Broadway Avenue. The mill was built in the 1870s, likely due to the advent of the railroad. A Mrs. Ziegler bought it in 1881; her son-in-law ran the business. In 1948, the mill was purchased by the Anheuser-Busch Company for use of the grain elevators. The mill itself was destroyed, but the elevators still stand.

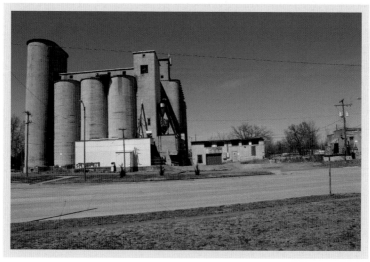

The Studebaker building was erected on the northwest corner of Campbell Avenue and Commercial Street in 1891. At the time, it was one of the largest buildings ever constructed in Springfield. It was owned by the Studebaker Company, a competitor of Springfield Wagon Company, and housed the Parce Buggy and Implement Company. It later became a warehouse for the McCormick Harvesting Machine Company. The building was destroyed by fire in 1983, and the area is now a parking lot.

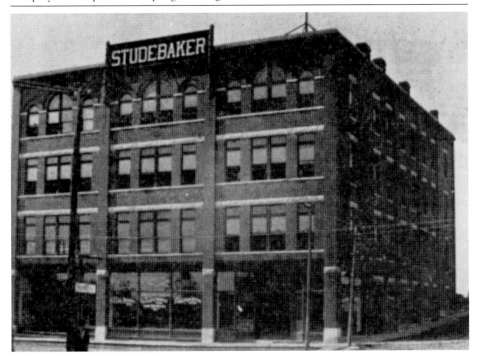

Rogers Auto Sales Company, previously Rogers Battery Company, was located at 229–231 West Commercial Street. The business was in that building from the 1920s through the mid-1940s. It was briefly vacant and, as with most historical Springfield buildings, has since housed a variety of businesses, including the Wilson Furniture Company. The furniture store closed in 1973. Prior to becoming Greene County assessor, LaRue Savage was associated with the business. (Past image, courtesy of the GCA.)

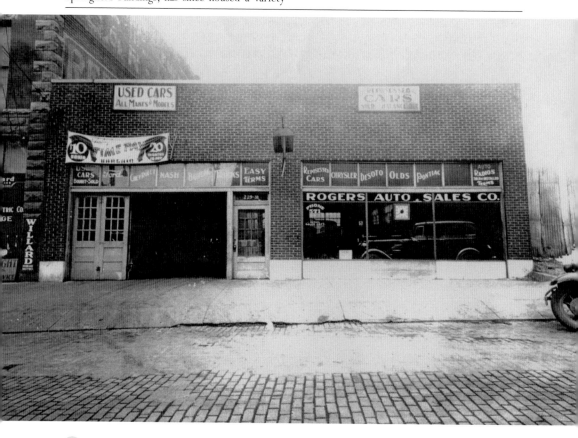

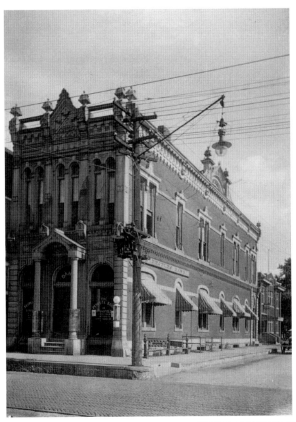

This once beautiful building was constructed around 1884 at the southeast corner of Commercial Street and Jefferson Avenue. It was originally home to the Bank of Springfield, which was bought by the People's Bank in 1915. People's Bank was formerly located down the street at Commercial Street and Boonville Avenue but moved to this building after the purchase. More recently, it was home to Ruthie's bar. The building remains, though in a significantly altered form. (Past image, courtesy of the Piland Collection, GCA.)

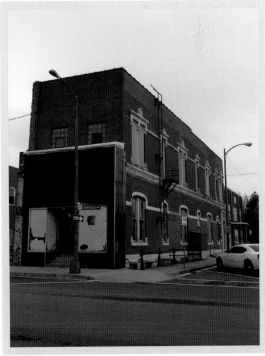

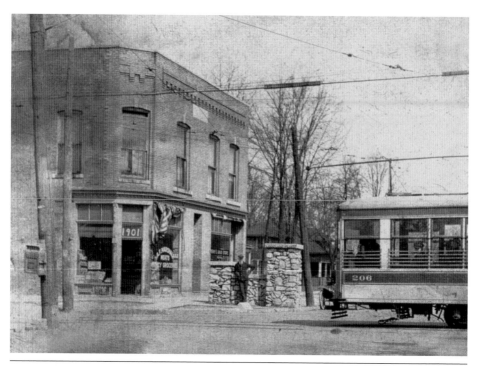

The Atlantic Grocery Company held the grand opening of its store at the corner of Broadway Avenue (then Broad Street) and Atlantic Street in February 1913. By 1919, the A.F. Marshall Grocery had moved in and stayed for some 20 years. In 1945, it was home to the Kurlette Beauty Shop, and then, in 1954, Helen Harrison held the grand opening of her flower shop. By 1970, the former shop had become apartments. (Past image, courtesy CU Collection, GCA.)

STREETSCAPES

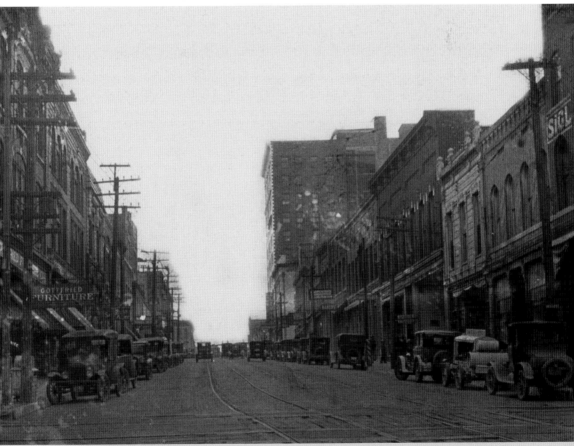

The 300 block of Boonville Avenue is one of the downtown streets that has been almost completely transformed. Once filled with side-by-side businesses, it is now primarily taken up with parking. One building that remains is the Gottfried Building, erected in 1890 and visible in this 1927 view of Boonville Avenue north from Water Street. The building was home to Gottfried Furniture Company until 1947. It is listed in the National Register of Historic Places. (Past image, courtesy of the GCA.)

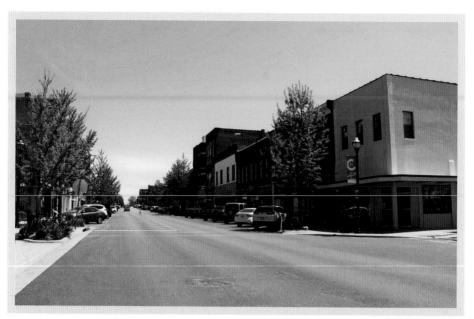

In 1927, Citizen's Drug Company was located at the southeast corner of Commercial Street and Boonville Avenue. Citizen's moved into the shop in 1925 after purchasing the Van Matre Drug Store. The move was publicly announced by pharmacists and owners W.T. Hoffelt and H.C. Forbes. Next door was Platte Hardware and a grocery store. This 1927 image was taken from Boonville Avenue looking east on Commercial Street. All of these buildings are still extant. (Past image, courtesy of the GCA.)

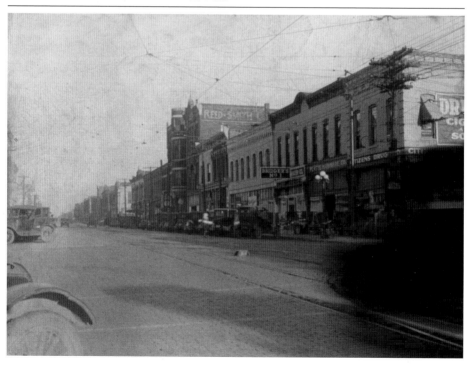

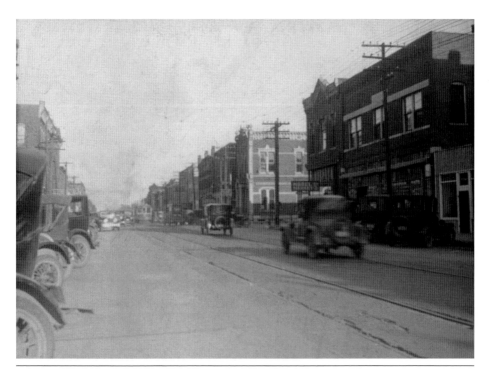

This 1927 image is looking east on Commercial Street from Robberson Avenue toward the former Emil Neu Clothing store, built in 1908. Neu had a clothing business in Springfield for over 40 years. Next door is one of several Model Markets that were in Springfield at the time, located at the corner of Commercial Street and Jefferson Avenue. This building was completed in 1891 or 1892. Both buildings are still standing and are now home to local restaurants. (Past image, courtesy of the GCA.)

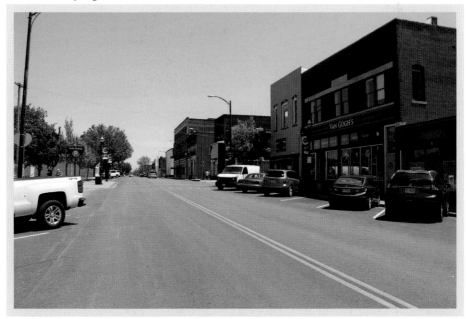

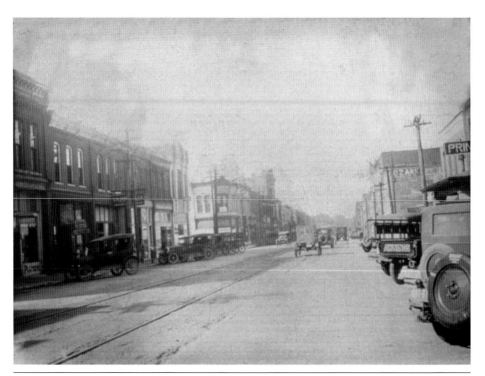

In the far left of this 1927 image is an 1890s Victorian-era building, then home to the business of Martin Herhalser, Ozark Plumbing Company. Since the 1950s, the Pizza House has occupied the building. Next is the C.O. Sperry and Company real estate office. The company stayed in this location through 1960, when the building briefly housed a skating rink and, later, an insurance company. (Past image, courtesy of the GCA.)

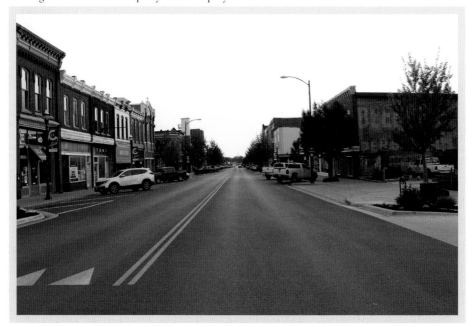

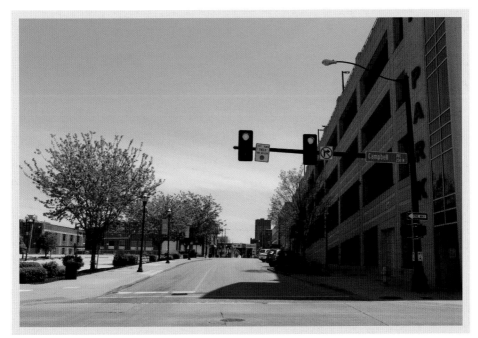

Garages were common on the 200 and 300 blocks of West Olive Street during the early years of the 20th century. The John C. Dysart Mule Barn was at the northeast corner of Campbell Avenue and Olive Street by 1906. The mule barn eventually became a garage and is now a parking lot. The Sutter Implement Company was on Olive Street by 1920. The south side of the street is now a parking garage. (Past image, courtesy of the GCA.)

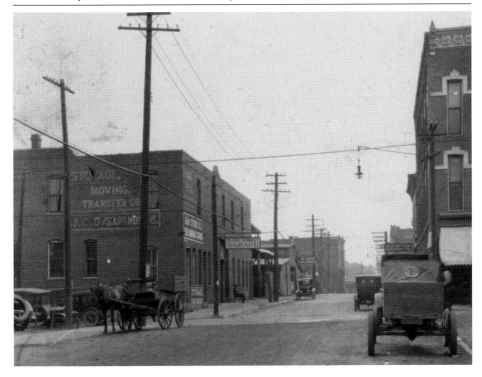

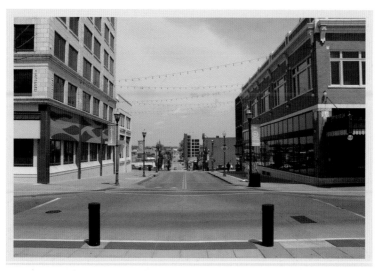

This 1932 image shows Boonville Avenue north of the public square. On the left is the Landers Building, and on the right was the Barth Brothers Clothing Company. The building is now home to the History Museum on the Square. In the distance is Lines Music Company, which later moved to Jefferson Avenue and McDaniel Street, and Gottfried Furniture store, both longtime Springfield businesses. Only the Landers Building and the former Barth's building still remain.

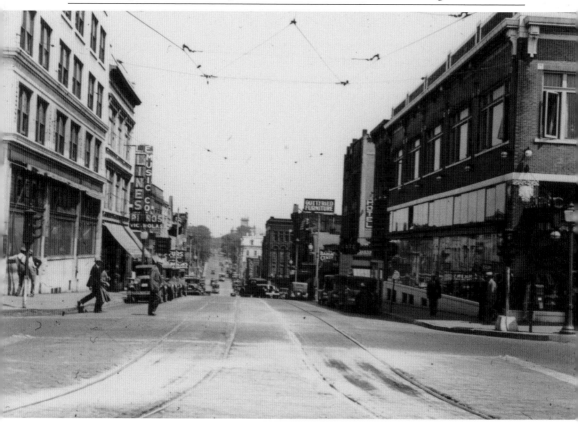

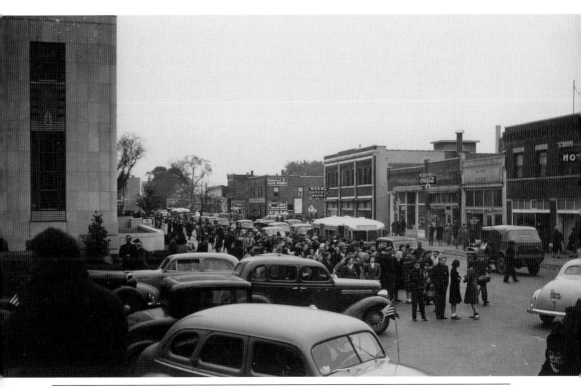

Looking north from the Midway Hotel at the northwest corner of Boonville Avenue and Central Street are a string of buildings and businesses that no longer exist. The part of the block filled with Ben Gist's barbershop, Smith Bros. Grocery, and Model Market in the 1930s is now parking. Model Market grocery stores were local and had shops throughout Springfield. A few of the buildings at the south end of the street still stand. (Past image, courtesy of the GCA.)

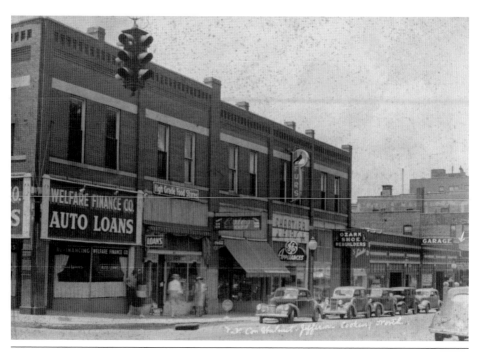

The Welfare Finance Company opened its Springfield office in 1934 and stayed at the northwest corner of Walnut Street and Jefferson Avenue through 1939. Next door in this 1930 image is Estes Market, owned by Herbert D. Estes. After having a formal grand opening for his store in 1932, Estes remained in this location through 1950. Ozark Shoe Rebuilders had several name changes, including D&W Shoe Shop and Williams and West Shoe Repair. (Past image, courtesy of the GCA.)

On the right in this 1924 image is a building constructed around 1895 and remodeled around 1960. On the left is Hall, the Jeweler, owned by E.B. Hall. Hall moved into this building at 330 South Avenue in 1915 and stayed for 15 years. Down the street is the Masonic Temple, built in 1906 and now a hotel. Next is the Landers Theatre, opened in 1909 by John Landers; it is still in use today. (Past image, courtesy of the GCA.)

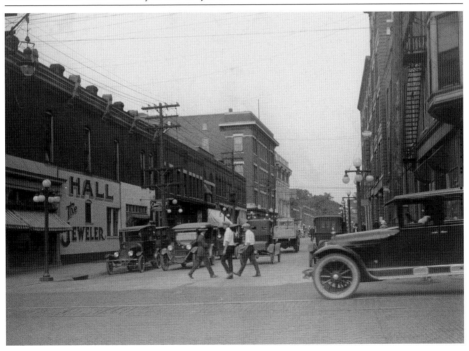

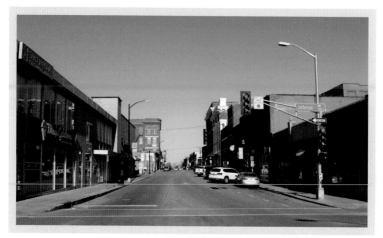

Looking west on Walnut Street from Jefferson Avenue in 1924, downtown was bustling with businesses and cars, much like the present. The Landers Theatre and the Masonic Temple, visible on the right, are still standing. On the left is the Springfield *Republican* newspaper office, published from 1908 to 1927. Also on the left is the Springfield Life Building, erected in 1906 to house offices. In 1928, it became the Savoy Hotel and, in 1933, the Hotel Seville. (Past image, courtesy of the GCA.)

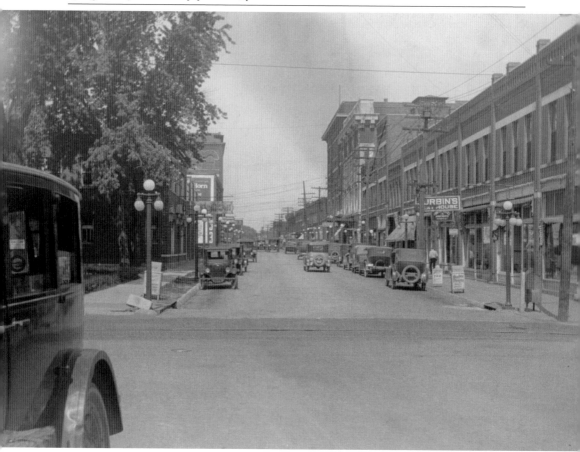

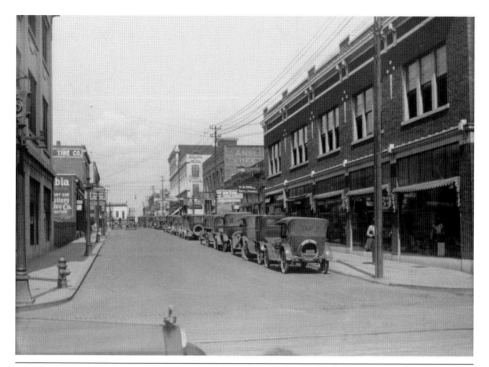

Much has changed since this view of McDaniel Avenue looking west from Jefferson Street was taken in 1924. The Bell building is visible on the left. Otherwise, the only building in this image still standing is a small, one-story structure on the west side of the Bell building that housed the Columbia Battery Company. The Martin Building, erected by Charles Martin in 1917, is gone, and most of the street is now devoted to parking. (Past image, courtesy of the GCA.)

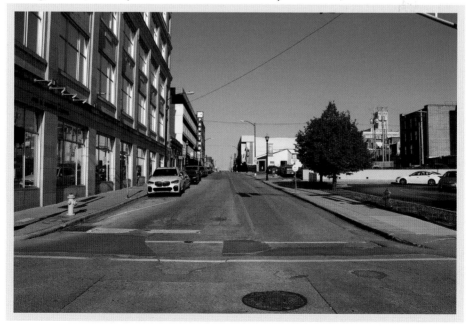

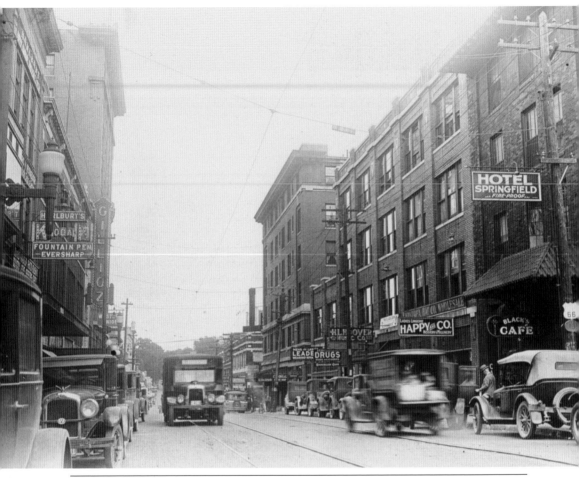

This 1927 image of St. Louis Street (now Park Central East) looking east toward Jefferson Street shows the Hotel Springfield, which was originally Hotel Sansone and, later, the Sterling Hotel. Happy and Company lingerie and millinery, Hoover Music Company, a drugstore, and a clothing store lead down the street to the famous Colonial Hotel, demolished in 1997. On the left is Hurlburt's Kodak shop and the Gillioz Theater, now a national historic site. (Past image, courtesy of the GCA.)

The Woodruff Building was completed in 1910 and, at 10 stories high, was Springfield's first skyscraper. John T. Woodruff, of Route 66 fame, was the building's owner and namesake. Woodruff sold the building to F.X. Heer in 1929. Next door to the Woodruff was Delmar Garden, a theater that was only open from 1911 to 1913. That building is gone, and Woodruff's grand building is now loft apartments. (Past image, courtesy of the GCA.)

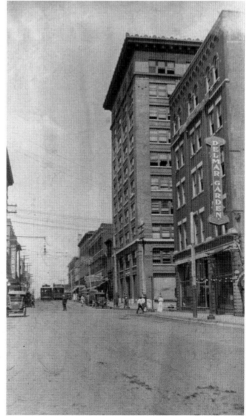

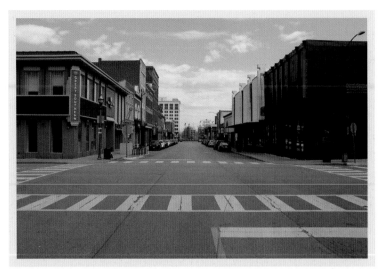

This 1880s photograph of Walnut looking north down South Avenue shows the two sides of Springfield, one that has disappeared and one that remains. The oldest remaining building on this block is the Rogers and Baldwin building, home to the first opera house in Springfield and a one-time venue for Susan B. Anthony. The trolleys are gone, as are the pillared sidewalk covers, but some of old Springfield still remains.

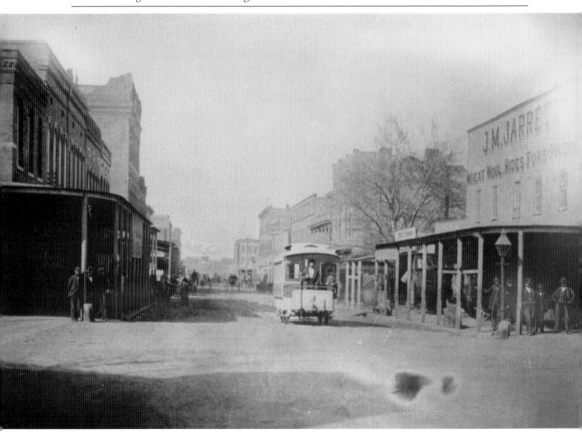

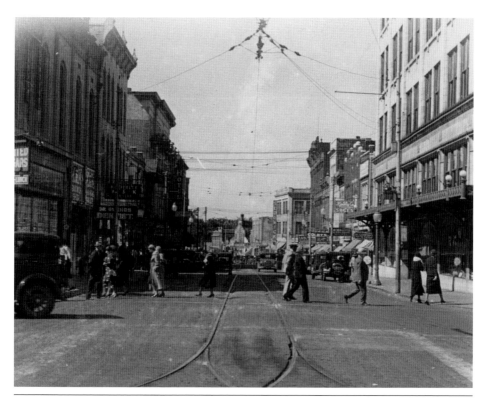

In this 1932 image of College Street looking west from the square, the once opulent Metropolitan Hotel is still visible on the left. On the right, on the corner of College Street and Campbell Avenue, is the Sedgwick Furniture store. Both buildings have long since been demolished. Shoe shops and clothing stores once lined both sides of the street. Of these buildings, a few do still remain, including the Heer's building on the right front of the image.

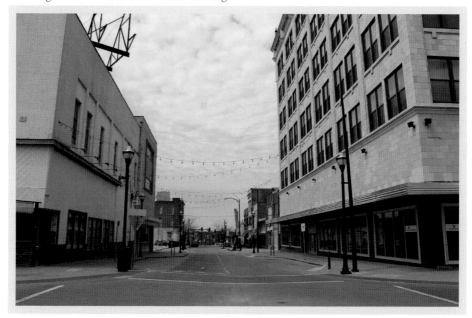

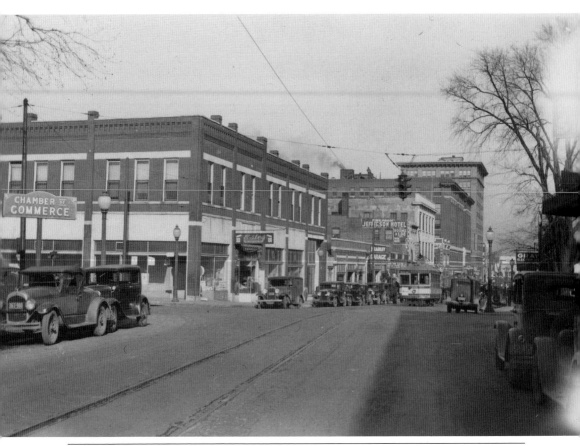

Built by 1913, the Jefferson Hotel still stands on Jefferson Avenue just north of Walnut Street. In 1919, the YWCA bought the hotel and converted it into a girls' dormitory. It was subsequently known as the YWCA Residence. By 1919, Headley Garage was located just south of the Jefferson Hotel. In 1929, Headley was gone, and the Al White Motor Company moved in, but only for a couple of years. The chamber of commerce house on the corner is long gone.

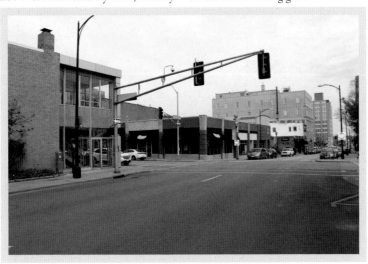

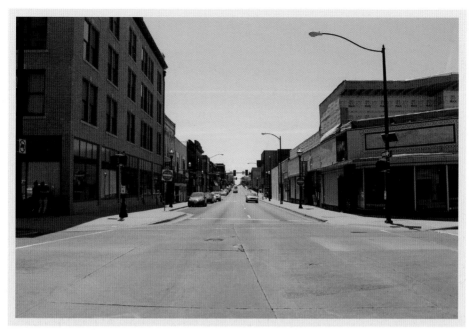

On the right in this 1924 image of Campbell Avenue looking south from College Street is the former Rubenstein's store. On the left is the former Busy Bee Department store, built in 1915. Busy Bee opened in Springfield in 1932. In 1934, Arthur Rosen moved to Springfield from St. Louis to manage the store; he eventually became the owner. The store closed in 1969 and fell into disrepair but has since been redeveloped (Past image, courtesy of the GCA.)

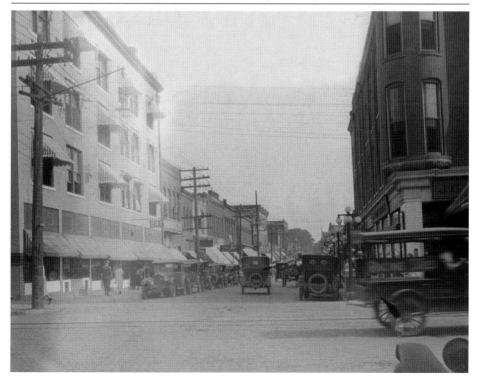

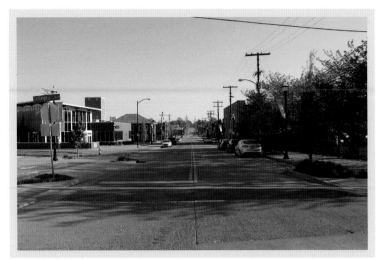

Main Avenue, looking north from College Street, has transformed over the years, looking significantly different in this 1924 image. On the left of this image are the Right Barber Shop and the Kirby Hotel and Kirby Café. In 1926, the front of the Kirby was demolished to make room for Main Avenue to be paved. The Kirby received a fancy new face-lift and continued in business until 1991, when it was partially destroyed by a storm. (Past image, courtesy of the GCA.)

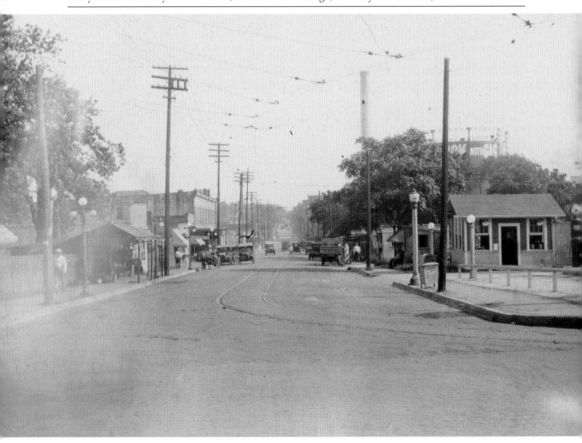

AROUND TOWN

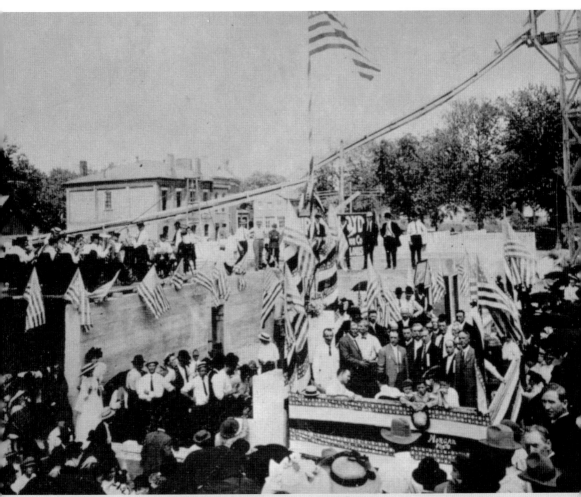

On July 16, 1910, Springfield citizens gathered to watch Mayor Robert E. Lee place the cornerstone for Greene County's future courthouse. By 1903, the county government had outgrown the old courthouse on the square. After much debate, land on what was then Center Street (now Central) was chosen as the site for the building now known as the Historic Courthouse.

Once considered the finest
hotel in Springfield, the
Metropolitan was a huge
structure built on College
Street between Patton Alley
and Campbell Avenue. Its
grand opening was held on
September 1871 with a grand
ball held on the mezzanine
floor. Known as the "Met,"
this was the second building
in Springfield to have an
elevator. This 1894 image
shows the hotel while still
somewhat in its glory days.
After being condemned, it
was demolished in 1954 to
make way for a parking lot.

METROPOLITAN HOTEL.

AROUND TOWN

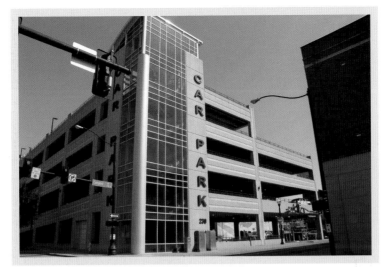

This 1894 image of the Denton Hotel, built by mid-1891 and located at 216 North Campbell Avenue, was one of the "big four" hotels that catered to business travelers. In 1923, Virginia Moore bought the lease, refurbished the building, and renamed it the Gateway Hotel. By the mid-1930s, the building was sold again and became the Hotel Grand. By the early 1950s, it was a parking lot and is now home to a parking garage.

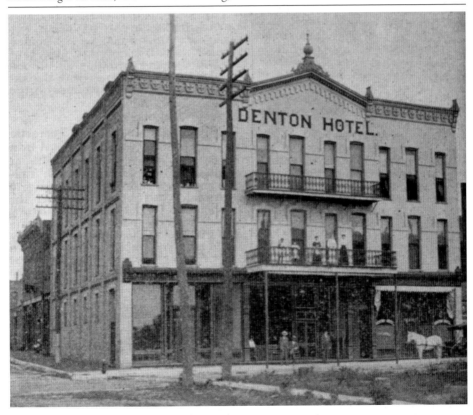

The Donovan Hotel opened on October 1, 1914, to much local anticipation. Several hundred people reportedly attended an informal reception held in the new hotel at 420 South Jefferson Avenue. Guests were invited to tour the 20 rooms, each with a private bath. Although it was a hotel, long-term tenants were permitted. The Donovan was considered quite a modern hotel and was in operation for about 50 years. (Past image, courtesy of the Piland Collection, GCA.)

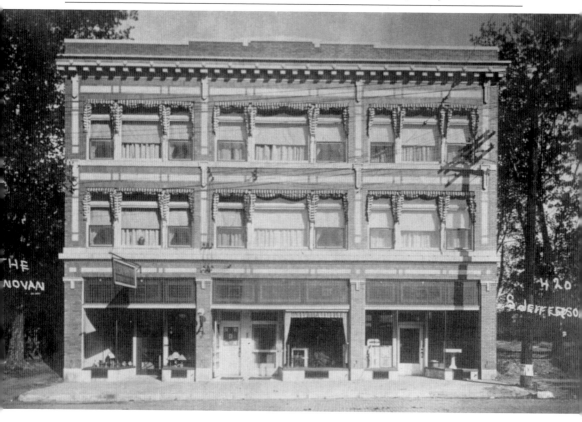

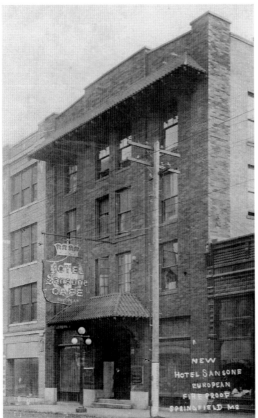

Tickets were sold for the grand opening banquet of the Hotel Sansone in January 1911. The new hotel was developed by John T. Woodruff and named for its proprietor, Charles Sansone. In 1926, new management changed the name to Hotel Springfield. Then, in 1934, the name changed again, this time to Hotel Sterling, a name that is still visible on the west side of the building. (Past image, courtesy of the Piland Collection, GCA.)

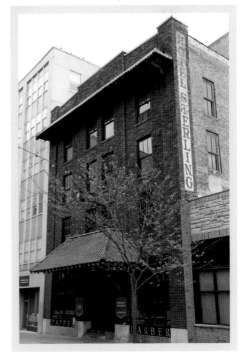

The Grand Opera House was located on the west side of Boonville Avenue, near Center Street (now Central), across from the City Hall Drug Company. Talk of building an opera house in Springfield began in early 1886. A year later, P.B. Perkins signed a contract to begin construction on Springfield's first opera house. It opened in March 1888 to great local fanfare. Unfortunately, a fire destroyed the structure in March 1896. The area is now a parking lot.

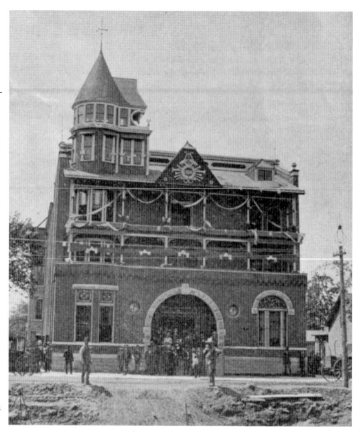

This undated image is of the YMCA, located at the southeast corner of St. Louis Street and Jefferson Avenue. The YMCA was organized in Springfield in 1888 in rented rooms on College Street. This building was constructed in 1900 but was destroyed by fire in 1911. In 1919, Madge E. Milligan had a two-story building erected that eventually housed several businesses and a cafeteria. In 1929, the Montgomery Ward store moved in. The area is now Jubilee Park.

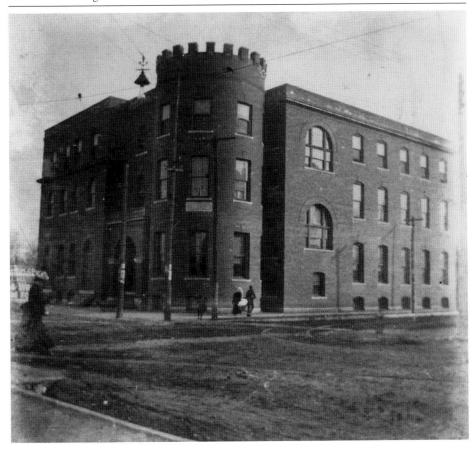

This image of the Springfield Club is dated 1902, just one year after the club was organized. Originally a social club, it was located at the southwest corner of Jefferson Avenue and Walnut Street. By 1919, the club had merged with other local organizations, creating the Springfield Chamber of Commerce. In 1959, the chamber still had a presence at this location, but by 1960, there was a new, modern building on the corner that currently houses several businesses.

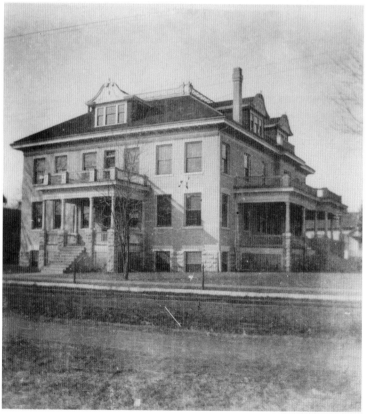

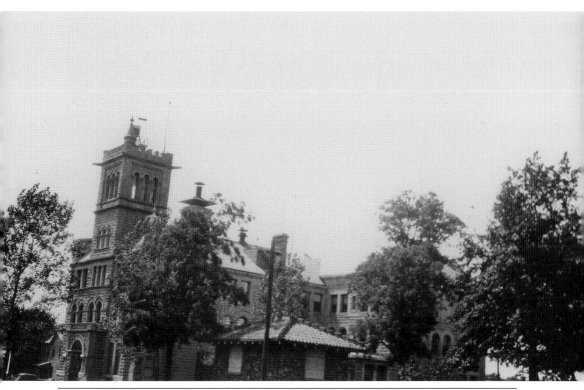

This c. 1935 image shows a Springfield city building that changed very little over the years. Originally the US Customhouse and Post Office, it is now known as the historic city hall. Constructed in 1894, the building underwent an expansion that was completed in 1914. Once home to the history museum, city council meetings are currently held there as well as landmark board meetings. It is also home to the fire department.

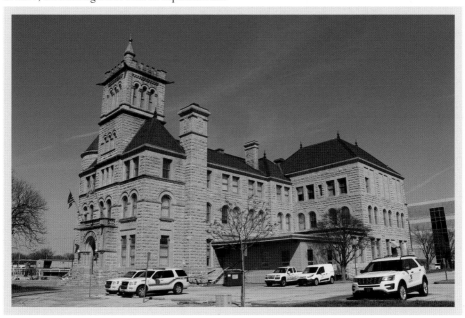

Known as the James Abbott House, this lovely old home was located at the northeast corner of Walnut Street and Grant Avenue. Abbott was a well-known Springfield businessman. He had the home built in 1870 for his wife, Mary Woolley Abbott. After their deaths, one of their daughters, Annie, lived in the 12-room house for a number of years. Tired of the upkeep, she leased the property to the Sinclair Refining Company, with plans for a service station on the lot.

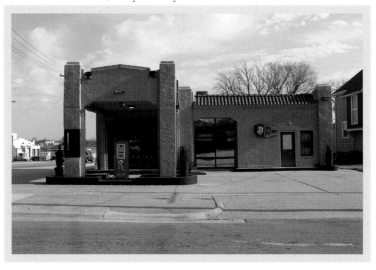

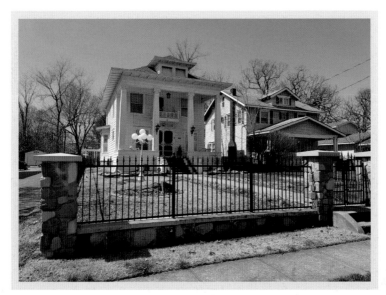

This stunning home still stands in Springfield's Deming Place, part of the Woodland Heights neighborhood. Known as the Deming House, it was built in 1909 by Ruben Israel and his brother-in-law Robert Deming. Israel and his family lived here for only a few years before selling. Since then, it has been home to several families. The house appears to have changed little since this image was taken in 1912.

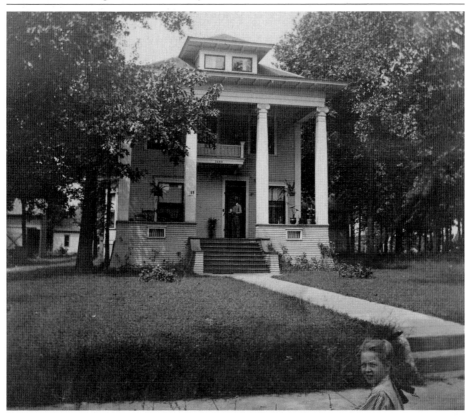

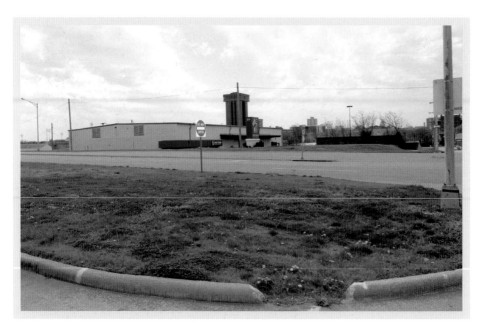

This 1933 image was the home of one of Springfield's most famous citizens, Sempronious H. "Pony" Boyd. During his long years in Springfield, Boyd served in several public offices, including probate clerk and mayor. In later years, he was appointed ambassador to Siam, now Thailand. He was also the judge in the "Wild" Bill Hickok manslaughter trial. Once located at the southeast corner of Chestnut Street and Washington Avenue, the house has long since been demolished.

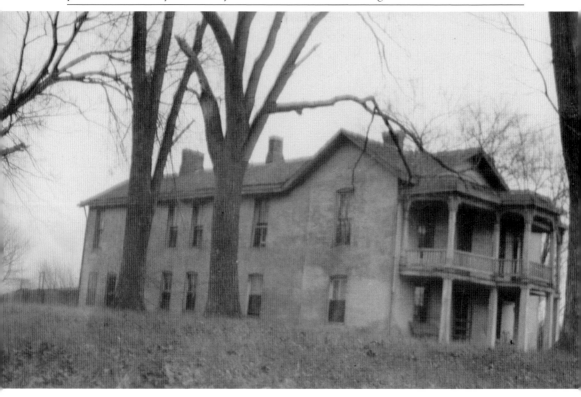

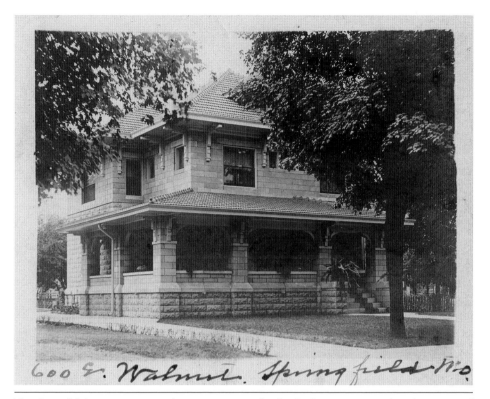

600 E. Walnut. Springfield Mo

This beautiful home on East Walnut Street is currently known as both the Holbrook-Thomas House and the Greystone House. It was built for Marcellus Holbrook and his wife, Ellen, around 1905. Holbrook was president of Springfield Furniture Company until his retirement in 1910. After his death in 1925, Dr. Arthur Thomas moved in. The house is part of the Walnut Street Historic District. (Past image, courtesy of the Piland Collection, GCA; present image, courtesy of EJB Photography.)

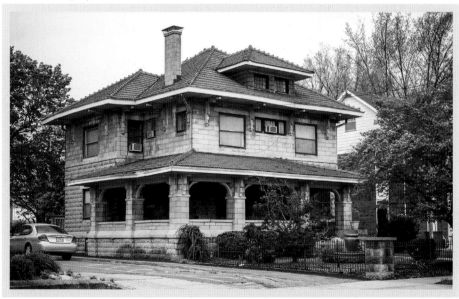

The Ollis House was located at what was then 1309 North Jefferson Avenue. Built around 1890 for Richard and Jessie Ollis, it was their home until about 1928 when they sold it to J. and Sallie Norman. In the mid-1920s, it stood right next to the Burge Hospital Annex and was eventually demolished to make way for the Cox North complex. (Past image, courtesy of the Piland Collection, GCA.)

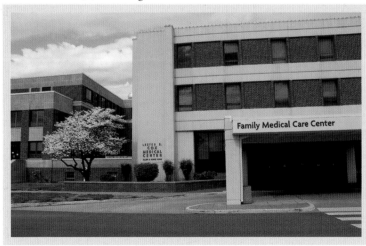

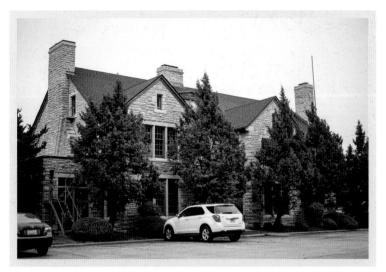

This undated image is of what is known as the Martin House, located on South Glenstone Avenue. Though it is now a law firm, it was built for John T. Woodruff in 1912 in his Country Club Addition. Woodruff later sold the house to Charles Martin, who owned the Martin Brothers Piano Company on McDaniel Street. (Past image, courtesy of the GCA; present image, courtesy of EJB Photography.)

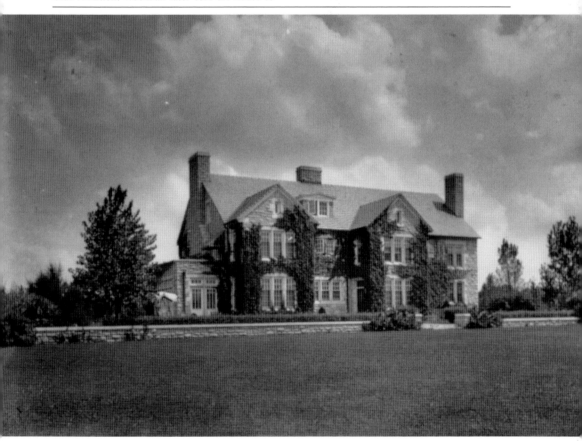

Discover Thousands of Local History Books Featuring Millions of Vintage Images

Arcadia Publishing, the leading local history publisher in the United States, is committed to making history accessible and meaningful through publishing books that celebrate and preserve the heritage of America's people and places.

Find more books like this at
www.arcadiapublishing.com

Search for your hometown history, your old stomping grounds, and even your favorite sports team.